500 Fairy Motifs

DEDICATION

*Nan and Grandad for their
memories and love*

Myrea Pettit

500
Fairy
Motifs

COLLINS & BROWN

First published in
Great Britain in 2005 by
Collins & Brown
The Chrysalis Building
Bramley Road
London W10 6SP

An imprint of **Chrysalis** Books Group plc

Copyright © Collins & Brown 2005
Illustrations copyright © individual artists 2005

1 3 5 7 9 8 6 4 2

British Library Cataloguing-in-Publication
Data: A catalogue record for this book is
available from the British Library.

ISBN 1 84340 302 1

Commissioned by Chris Stone
Project managed by Carly Madden
Designed by Paul Wood

Reproduction by Anorax Images Ltd
Printed and bound in China by SNP
Leefung Ltd

Front Cover: Myrea Pettit
Back Cover (top to bottom): Stathis
Karabateas, Andy Duroe & Selina Fenech
Back flap: Maria Van Bruggen
Page 1–7: Myrea Pettit

Copyright

We would like to establish an understanding
that the illustrations here are the intellectual
property of the originating artist and it is their
right not to be copied for financial gain, but
request to be used according to the conditions
published on their websites. If you want to use
the work of an artist, research their website and
their conditions before contacting them. It is
against worldwide copyright laws not to
protect the intellectual property of artists.
Ignorance of copyright laws is not an excuse.
Artists are encouraged to prosecute those who
break the law. Please read this site:
http://www.rightsforartists.com/

Artists generally accept most reasonable
personal requests. With tattoos it would be
considered a courtesy to purchase an image as a
card or picture, so the artists can earn their
living. Some artists actually post pictures of
their clients tattoos on their websites, please
consider this as support for your chosen artist.
Artists also post tutorials on their sites showing
how they draw and paint an image and there
are even images that can be copied down in
outline for children to trace and colour. Other
sources of interest are embroidery and stencils;
many artists do have facilities and contacts
where their images can be purchased as charts.

There are any number of internet requests
by clubs and individuals for Paint Shop Pro
enthusiasts, for stationery, tags, siggies and tubes
etc. Many artists have in the past supported this
but their trust has been abused when their
conditions of origination and identification
have not been observed. Images have been
altered and misused, purporting to be the work
of others and even sold illegally. Many artists
will now no longer support
these hobbies.

Introduction

The Fairy Path

Thank you for joining me on the journey along my fairy path. Painting fairies can be the beginning of a special journey, it is a way to express and open your soul to a mysterious and magical world and in doing so it can enlighten the innocent with dreams that they too can be at peace with nature's greatest inspirations.

I am often asked for my images and drawings for colouring and tracing or for stencils, stickers, cards and tattoos, or simply just for inspiration. I am delighted to present such a varied collection of 500 fairies, illustrated by many artists from around the world who have joined me on my fairy path. I hope that you will be inspired by their thoughts and creations and will come and look us up, our websites can be found in the index at the end of this book.

For as long as I can remember, I have always believed in fairies. As a little girl I remember playing in the garden with my sister and the fairies were always beside me, along the meandering garden path, dancing in and out of the sweet smelling flowers. It was my own magical world, a place I could escape into. I loved the early morning stillness, the dawn chorus, the glistening spider's webs, the dew drops, the sunbeams, God given glorious colours and perfumes, and the buzz of the insects as they went about their business. I felt I needed to go there, for it was such a playful, happy place to be and I never seemed to have long enough there. It was where I felt so creative. Everything was innocent and naturally beautiful, filling me with energy.

My father tended our fairy garden with his magical green fingers; he kept it meticulously, it was full of herbs and vegetables, fruit trees and gooseberry and currant bushes, attracting colourful butterflies, moths and

bees. We would pick the ripened fruit and make jam or home-made wine. I was fascinated by the garden. It was in the humidity of the moving compost heap where I saw little creatures, there among the huge mushrooms that suddenly appeared overnight, or the big rhubarb plants with their big leaves, amidst the sound of the neighbour's pigs snorting and squealing behind the big wall. In the crevices of the brick wall there was lichen and fungus growing with all sorts of creepy crawlies to spark my imagination.

Sometimes when we were meant to be picking fruit for Dad's home-made wine, it took my sister and I much longer than it should have done. We would linger by the stacked flower pots trying to entice the fairies out. There were many creatures in our magical garden; we had a hedgehog, a tortoise, ferrets, frogs, toads and bird boxes. I loved to draw them all and dress them in suits and clothing. I used to see them as a little family of garden creatures.

It was my older brother Mark who initially started me drawing. His drawings were outstanding and I remember following him everywhere trying to see what he was drawing. As polite and caring as my brother was, I am sure it got on his nerves but he never complained. However I decided I would have to go it alone and see if I could also develop the same amazing techniques. With just a few pencils, paper and a little watercolour paint. I spent every moment of every day drawing the energies I saw in my little world alongside the fairy path. Most of my influence came from my Mum who loved fairies ever since she was given a book as a child called *A Day in Fairyland*, illustrated by Swedish artist Ann Mari Sjögren (see pages 168-71); it was a treat to be allowed to see that book.

The Fairy Prince I met when I was eighteen, to live happily ever after with, turned into a disastrous relationship. My fairy path came to an abrupt end and the magic just drained away. I did not see the trees or fairies for eleven years; the beauty in my life was but a distant memory and darkness was all around. Purely by chance a miracle happened, I was introduced to a retired business entrepreneur, who listened intently to my distressing life

story, and encouraged me to recover my confidence and self esteem, and find that fairy path again. My drawing skills were rusty and my faith in my ability slow. To thank this fairy godfather and mentor, I painted him the glow-worm fairy to hang in his home. "I am going to hang this on the internet" he said, "so this fairy light may shine for all to appreciate and follow the fairy path".

The websites grew and interest developed in my work. I drew more and more fairies and sure enough soon I was joined, one by one, to a great family of fairy artists who wanted to collaborate together, each with a passion for the spiritual connection of 'Fairy'. How true is that genius illustrator Brian Froud when he said these words to me: 'The secret is not to give in, you have to keep going, you just have to believe, you've got to believe! It is interesting, once you step onto the fairy path, which I did once, it's a simple step, there is no way off, they don't want to let you off! You can if you want but you know it would be a terrible thing to do.' Since then along my path, I've had a fairytale meeting in Sweden with Ann Mari and met Alan Lee and many other great fairy artists and illustrators. The path is now spreading all over the world with wonderful artists, all who have their own stories to tell and beautiful fairies to share. Join us in this book to give love and inspiration to others.

Bright blessings
Myrea Pettit

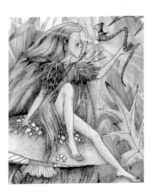

MYREA PETTIT

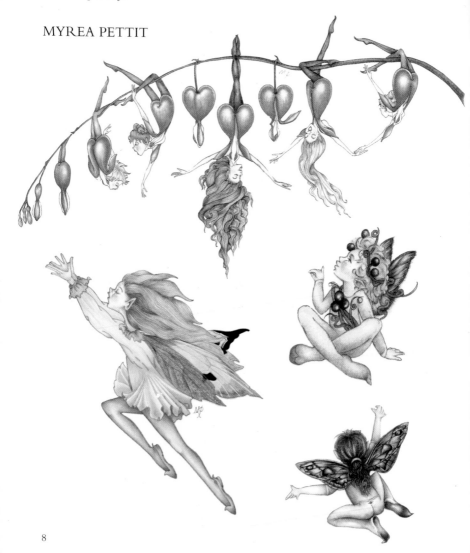

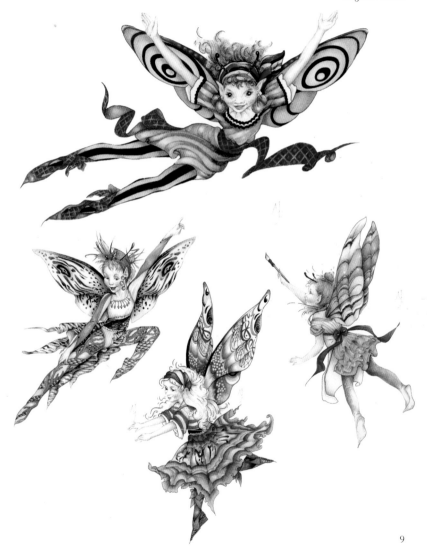

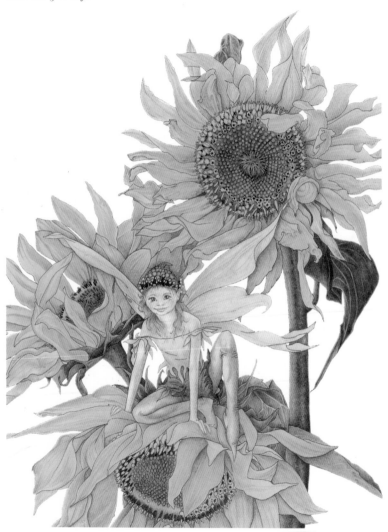

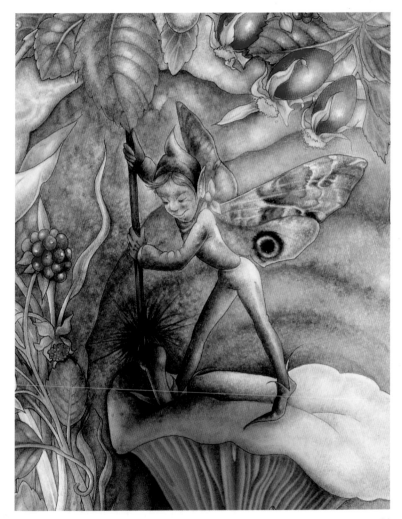

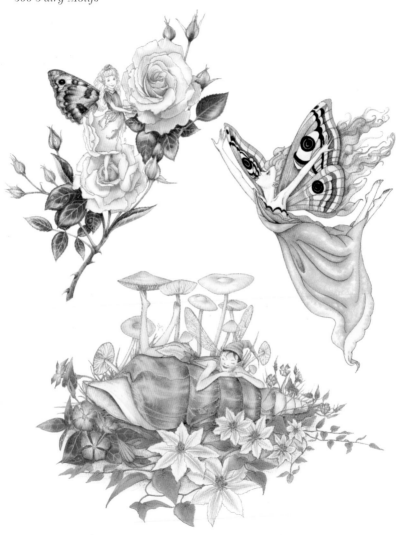

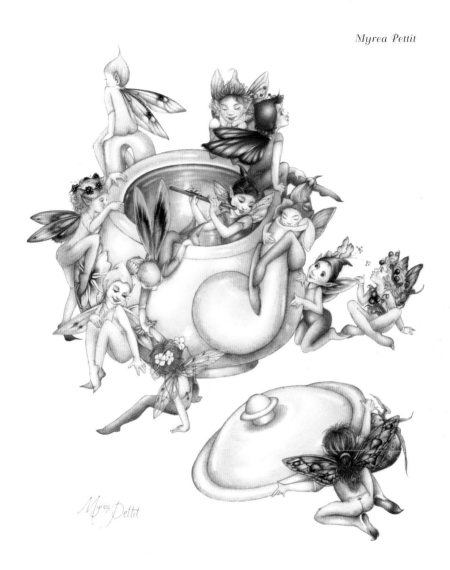

Myrea Pettit

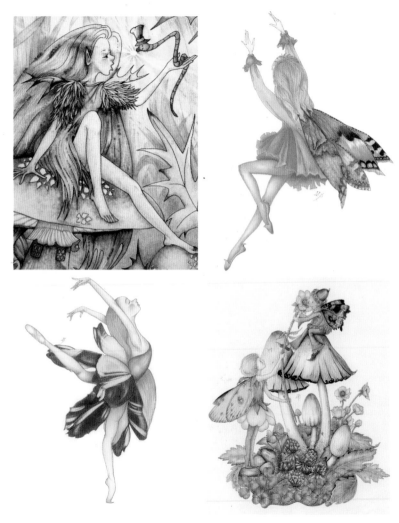

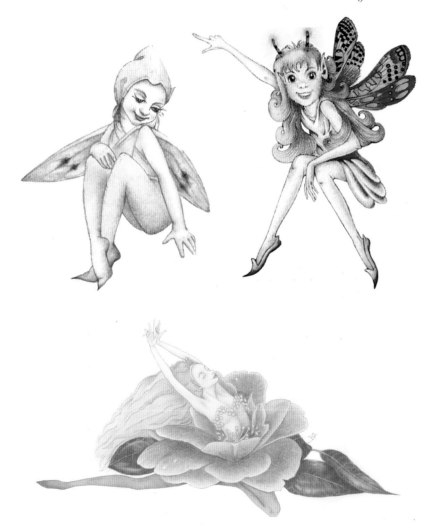

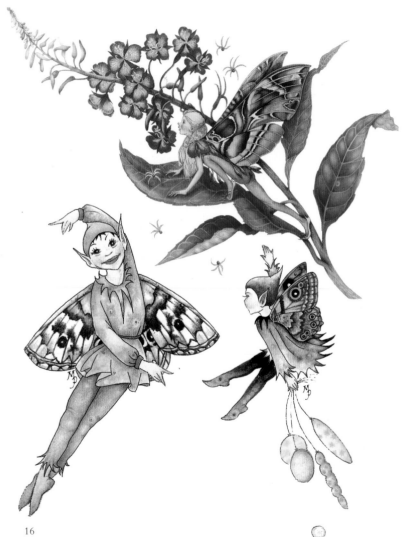

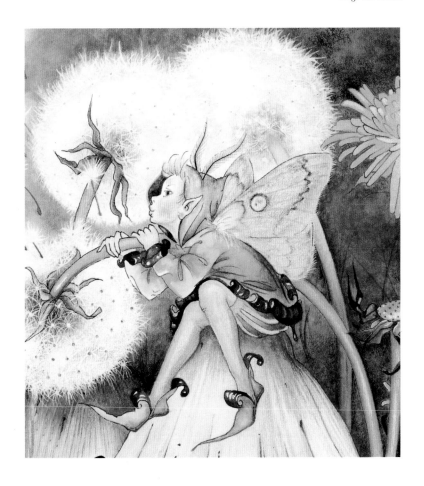

BRIGID ASHWOOD

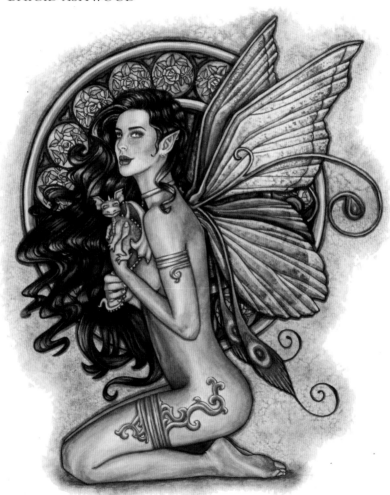

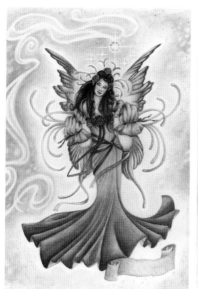

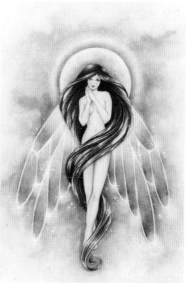

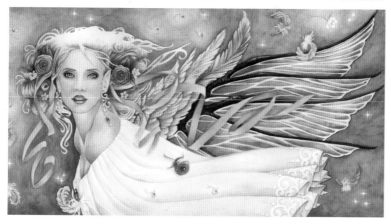

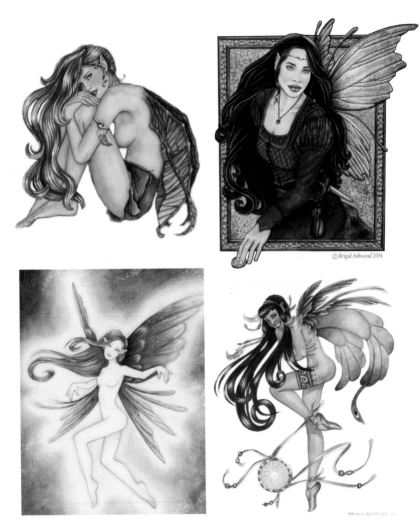

© Brigid Ashwood 2004

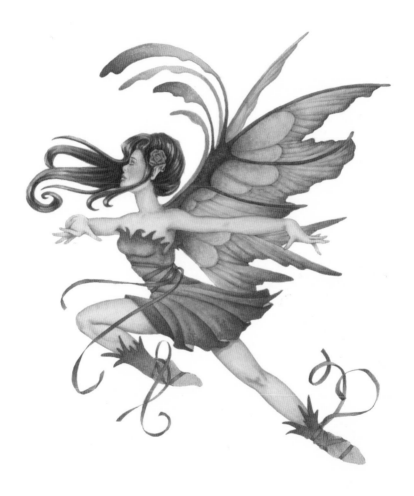

JASMINE BECKET-GRIFFITH

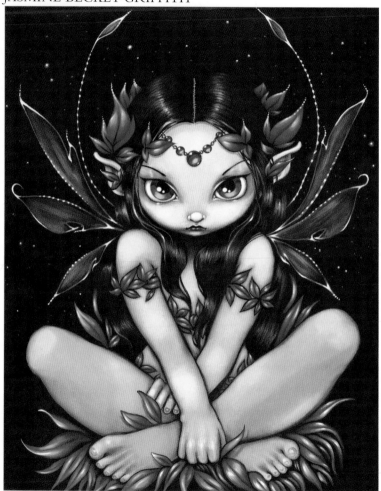

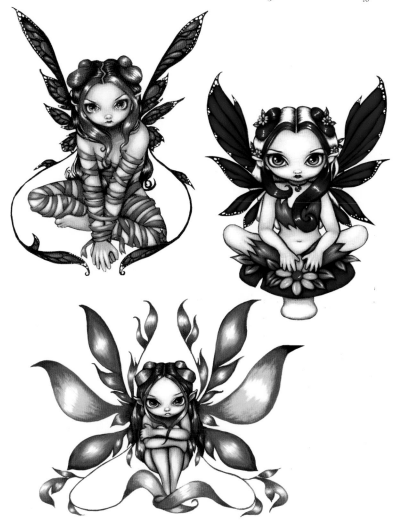

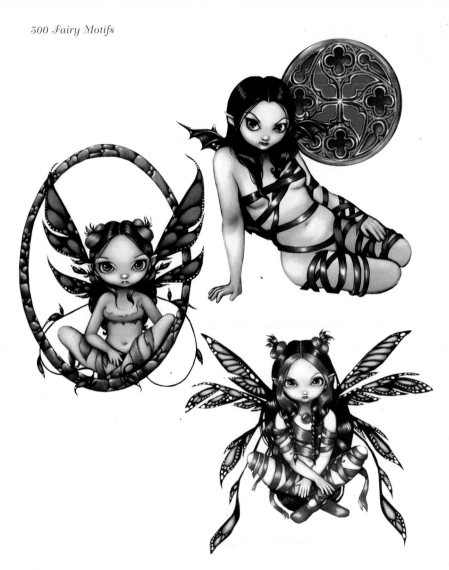

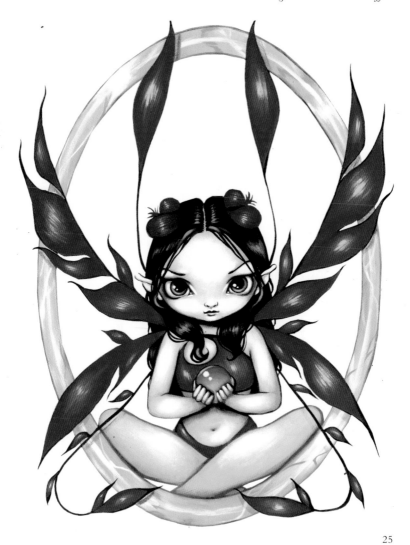

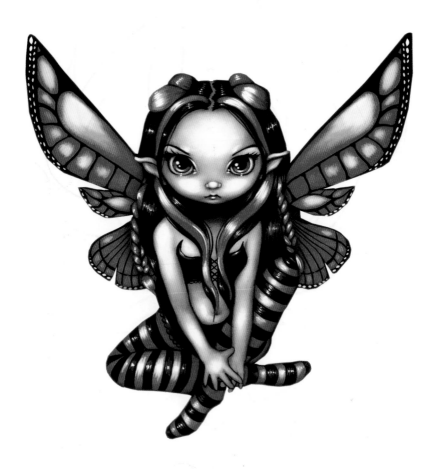

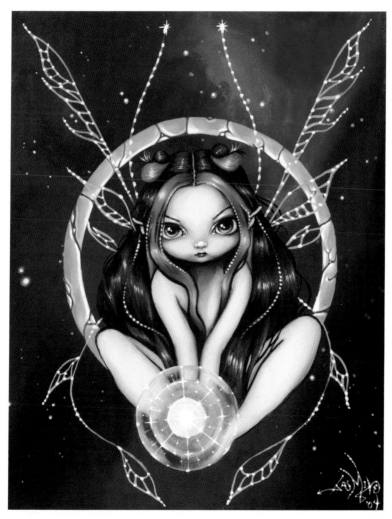

MISTY BENSON

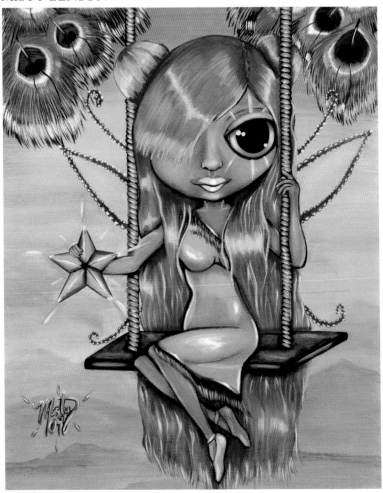

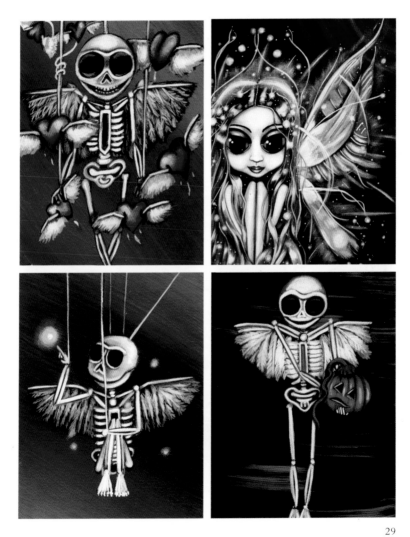

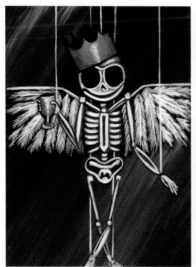

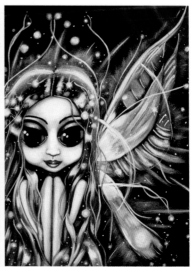

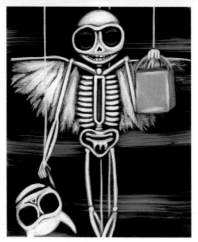

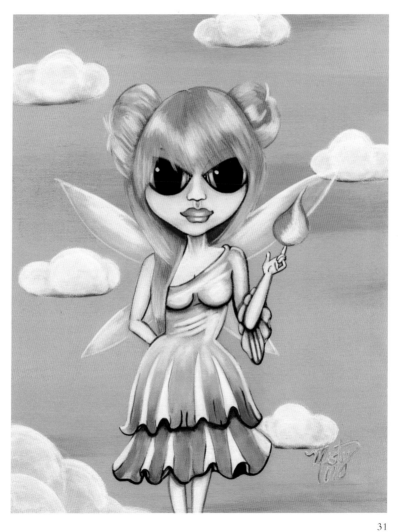

LINDA BIGGS

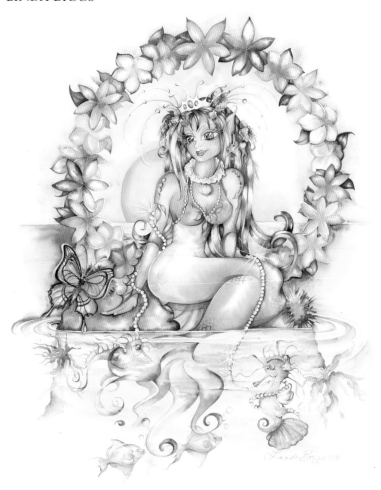

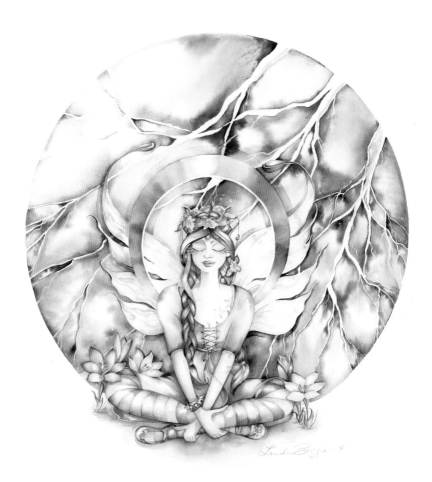

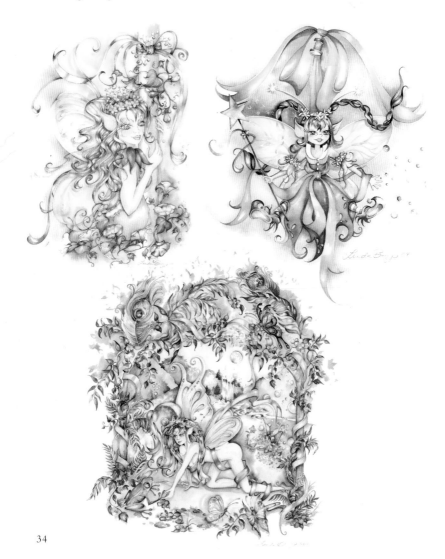

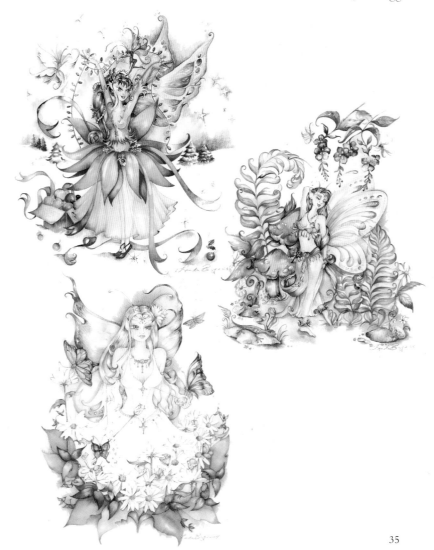

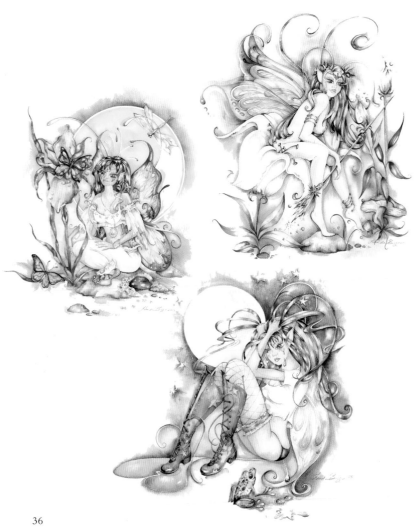

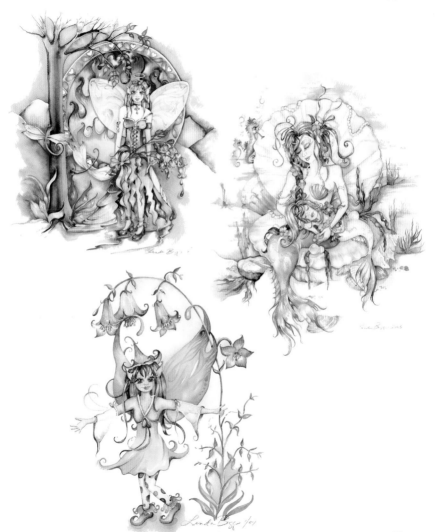

WALTER BRUNEEL

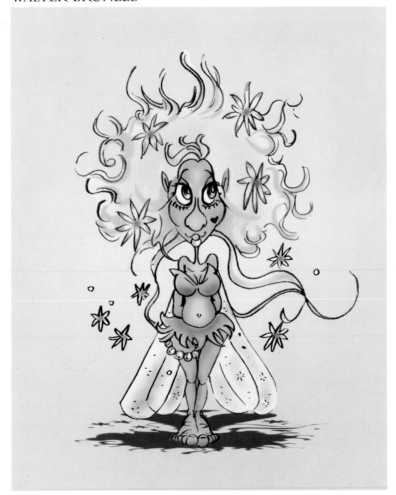

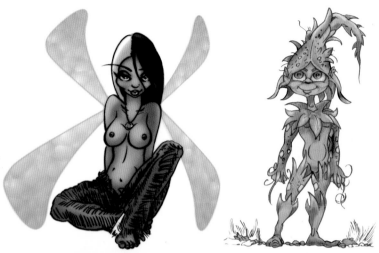

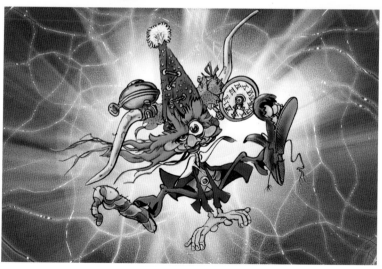

JAQUELINE COLLEN-TARROLLY

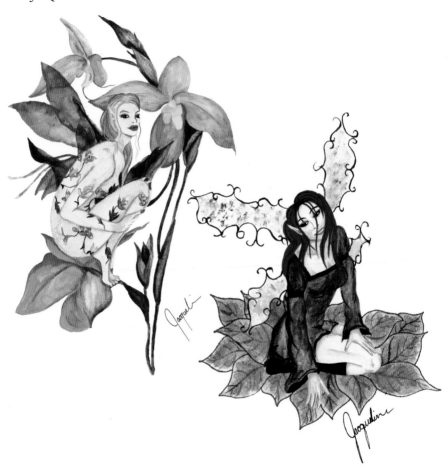

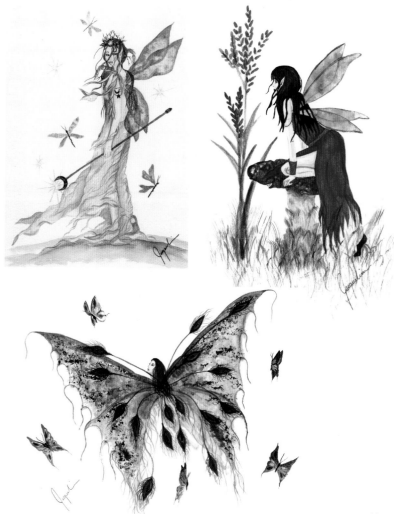

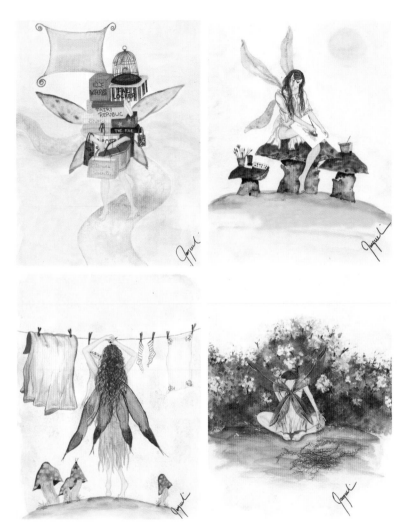

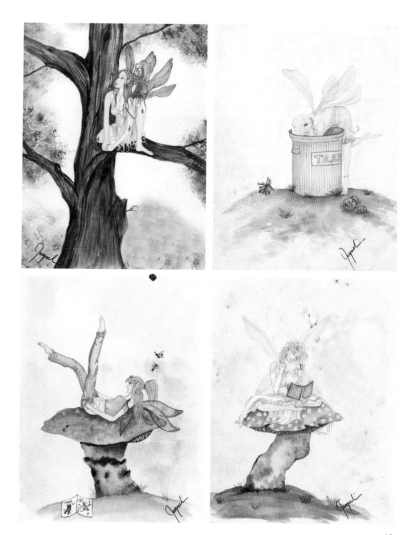

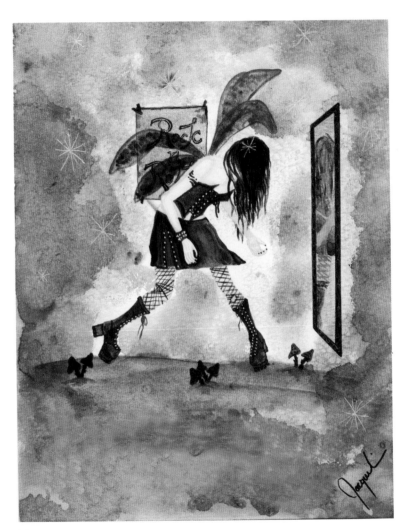

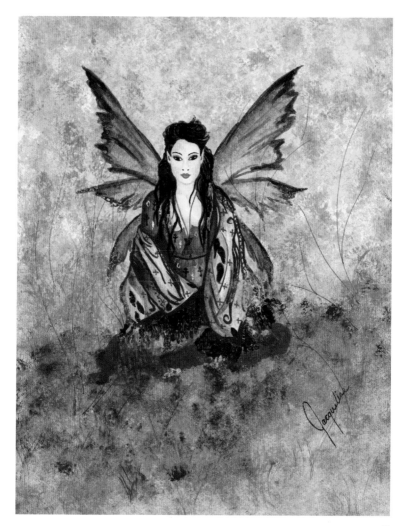

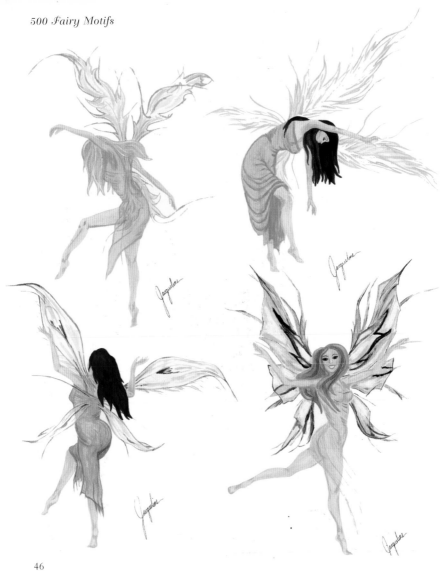

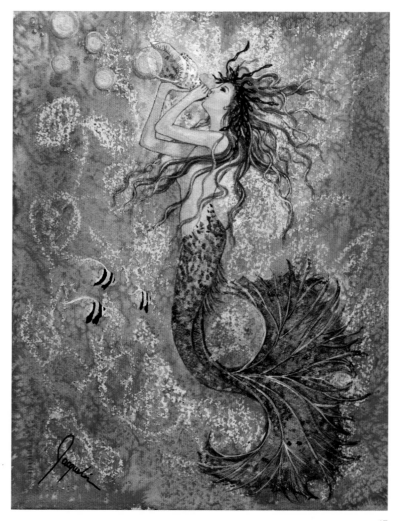

KATHLEEN A. CYR

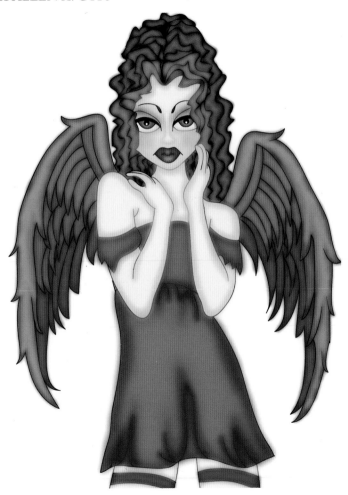

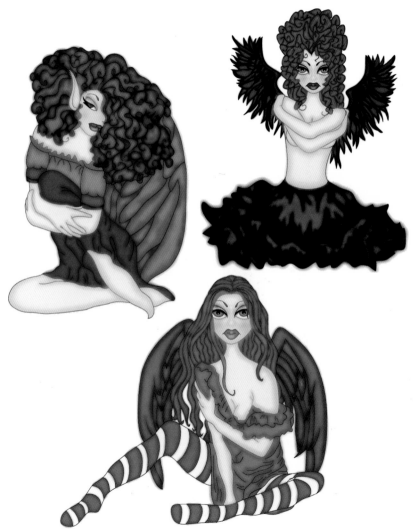

49

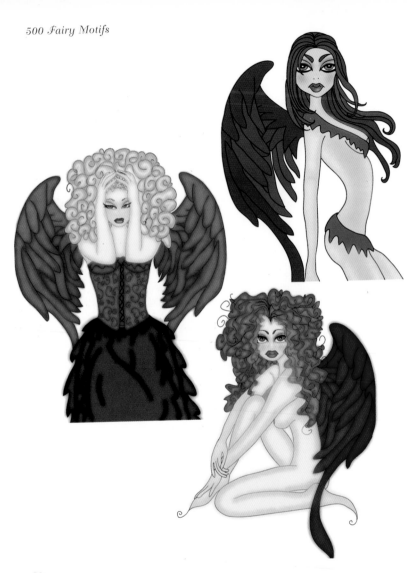

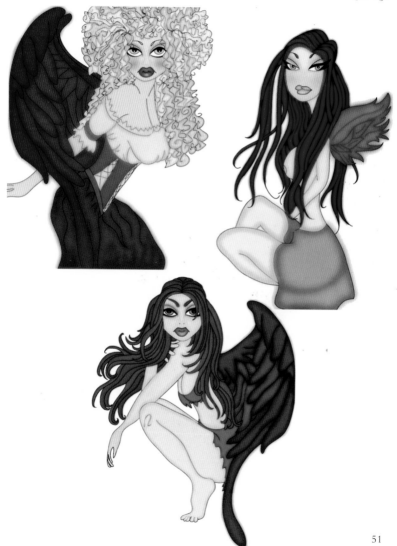

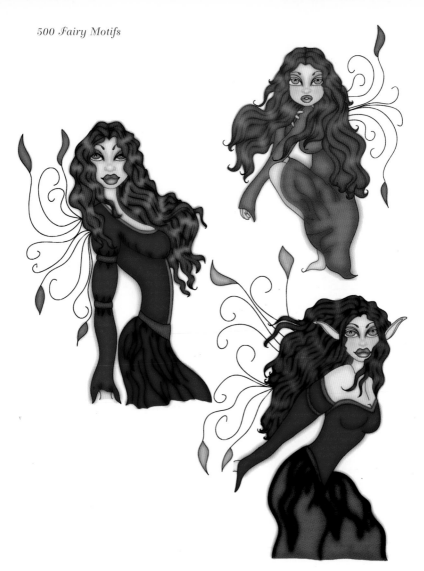

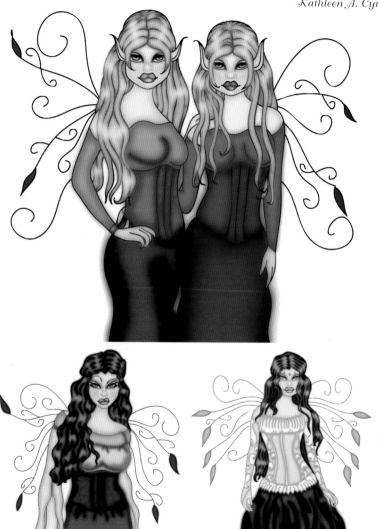

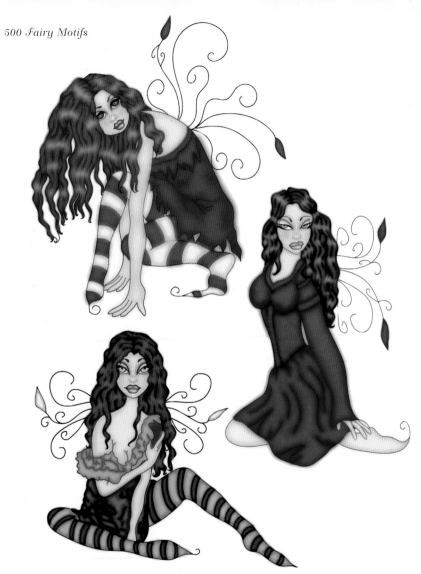

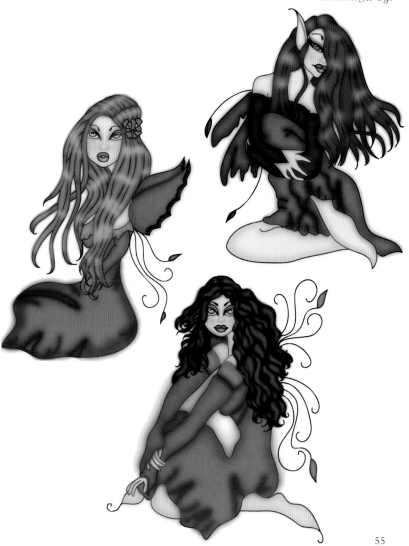

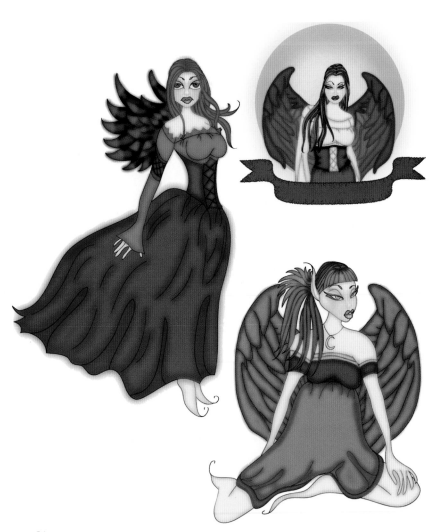

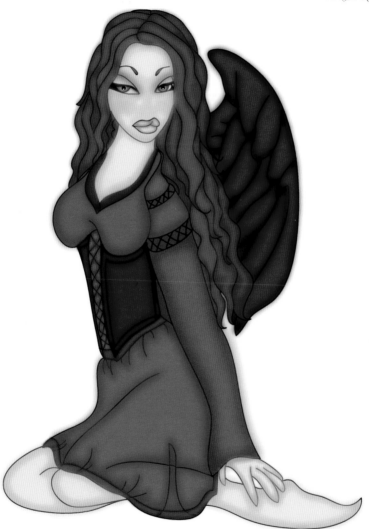

MEREDITH DILLMAN

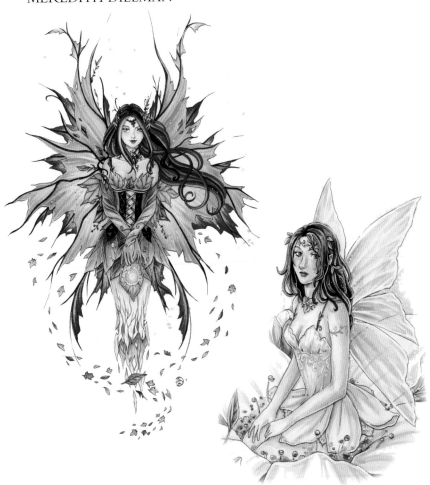

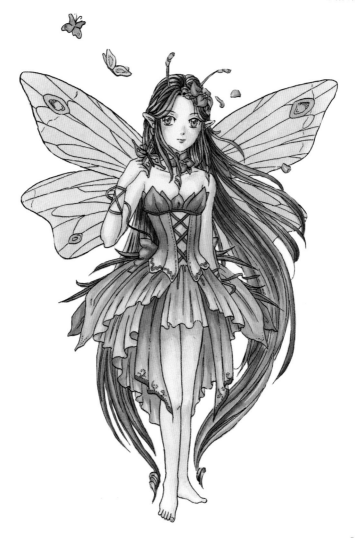

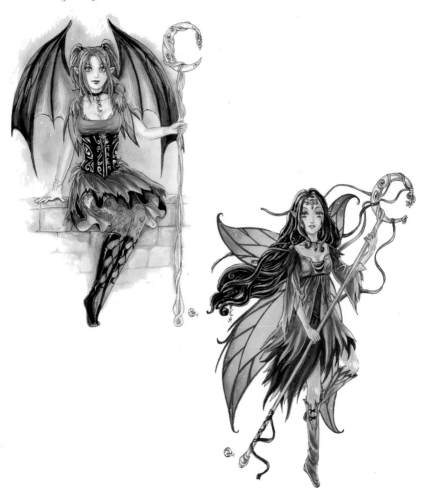

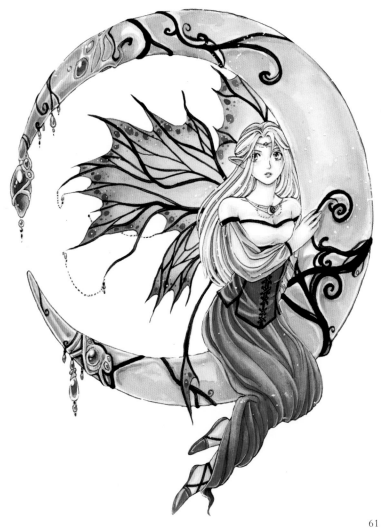

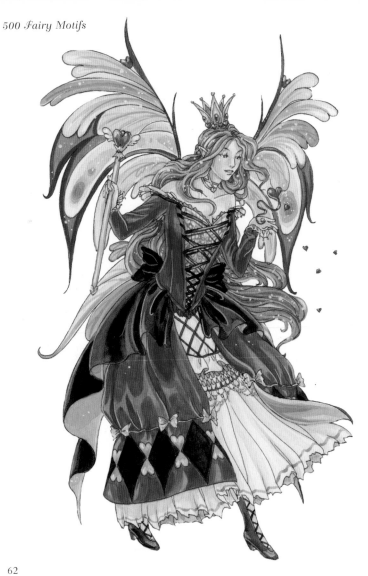

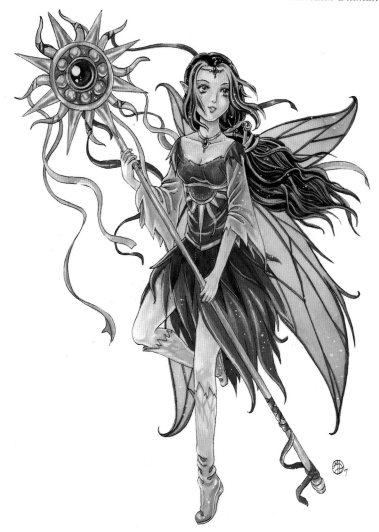

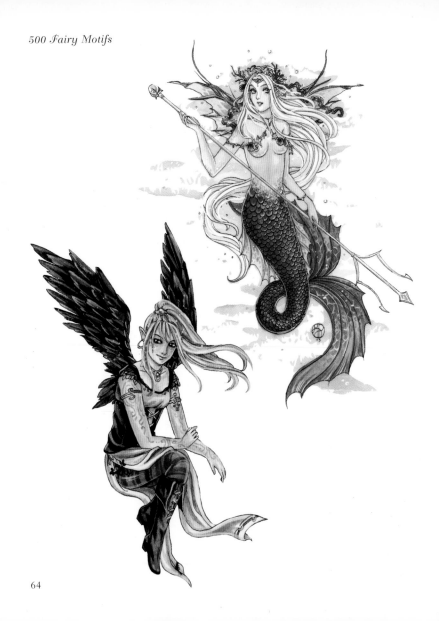

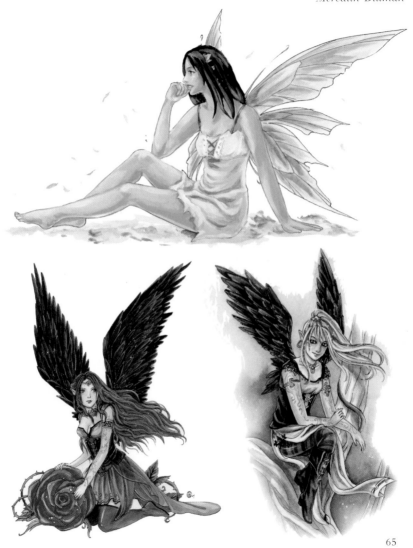

ANDY DUROE

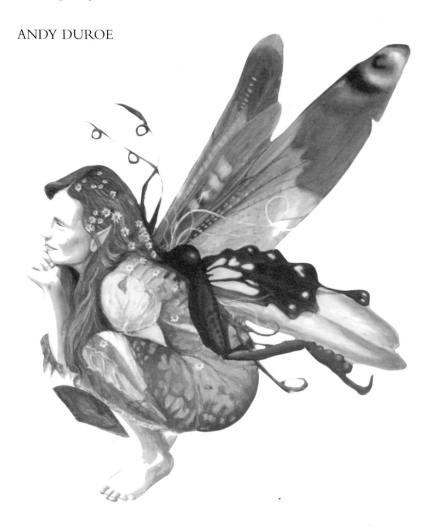

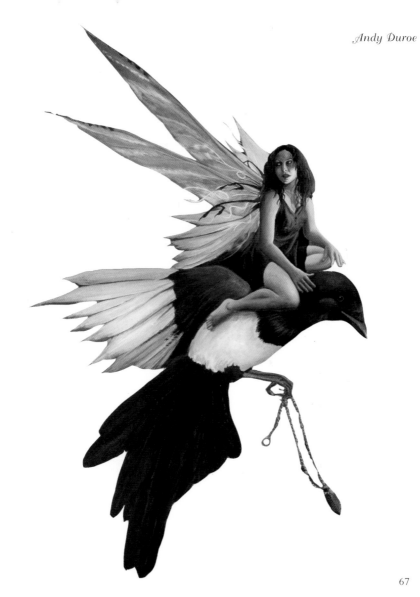

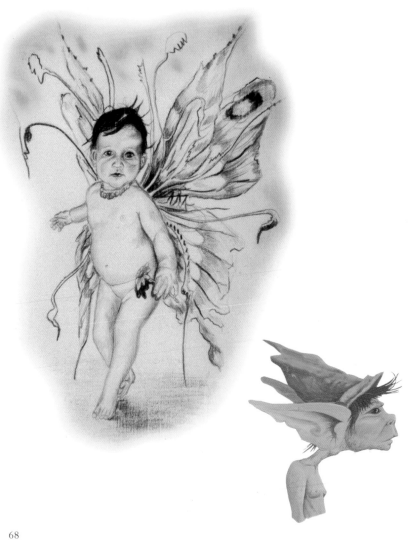

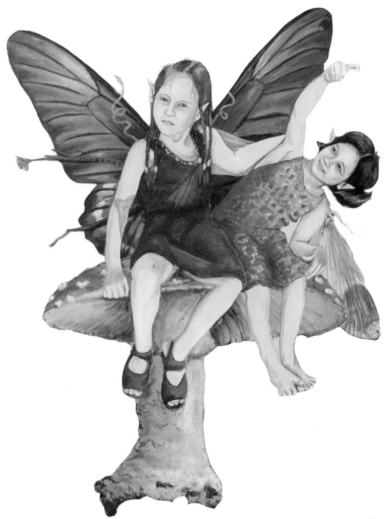

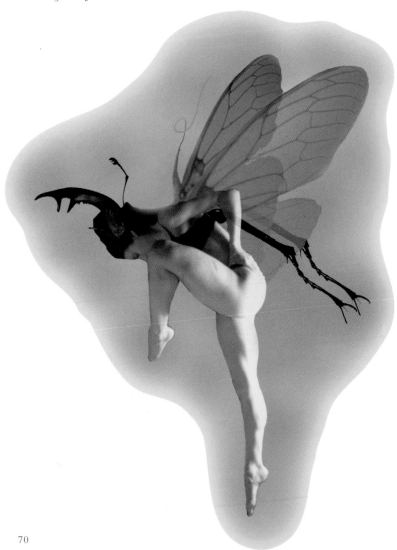

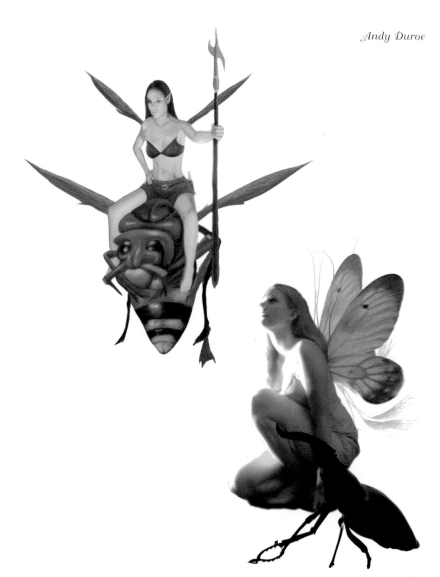

SELINA FENECH

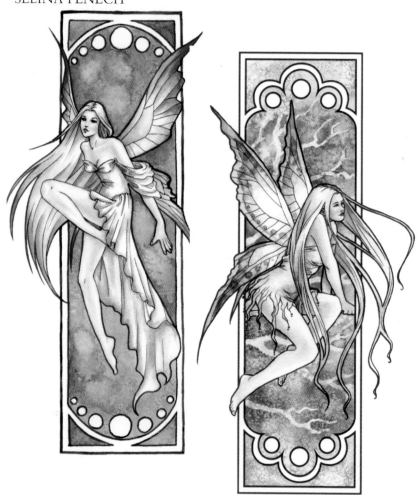

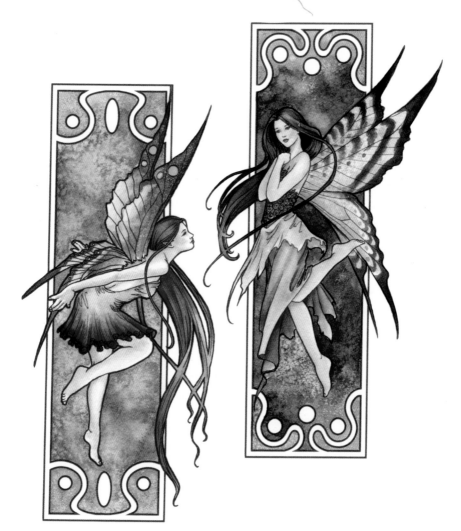

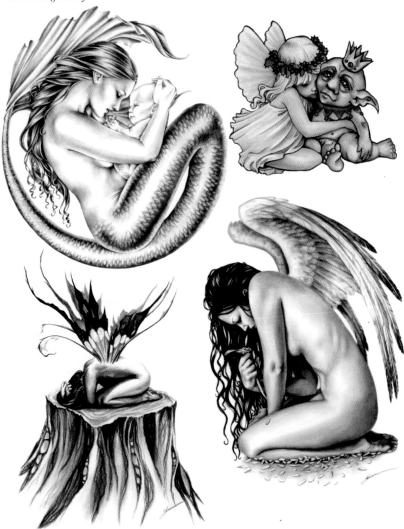

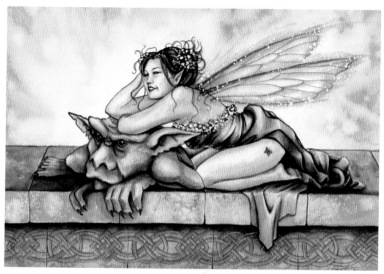

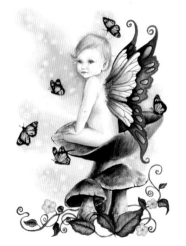

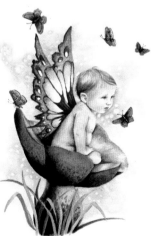

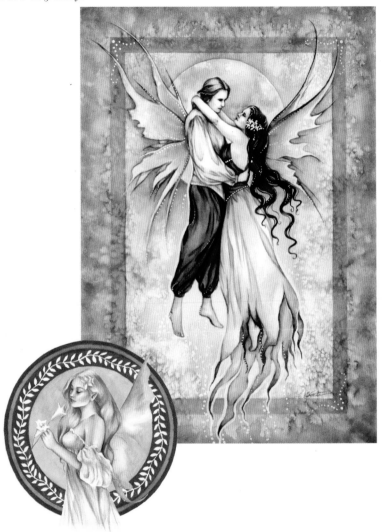

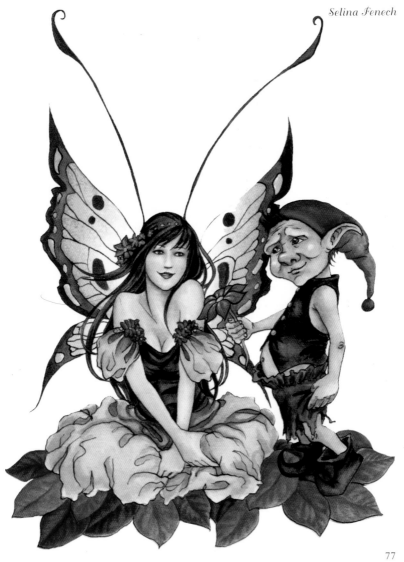

ANNA FRANKLIN

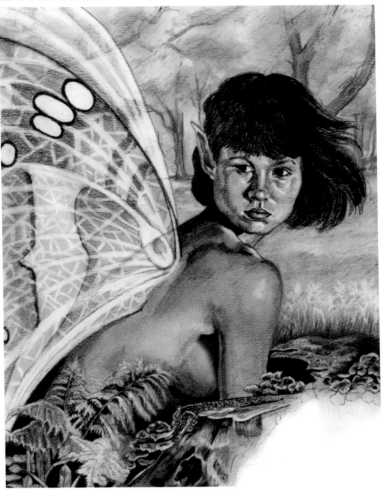

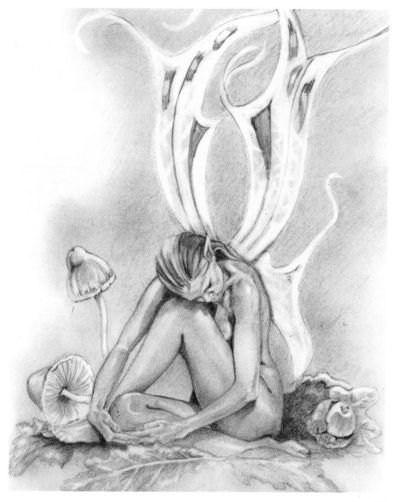

JESSICA GALBRETH

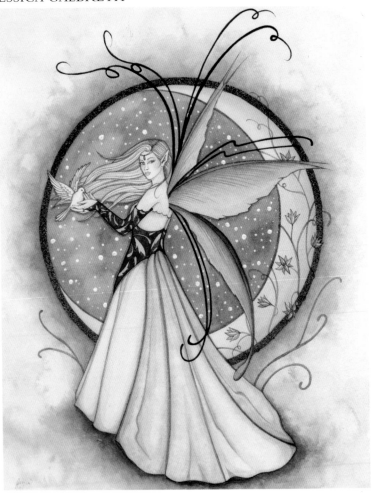

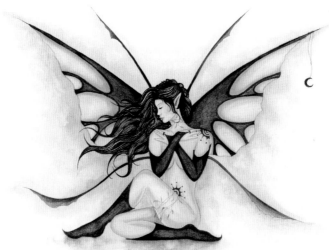

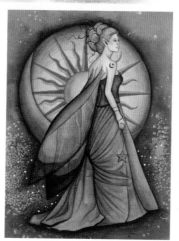

VICTORIA GRIFFIN

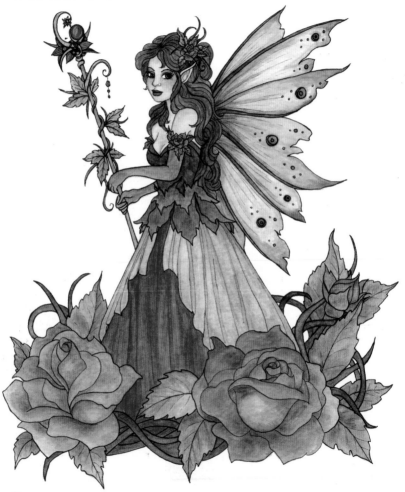

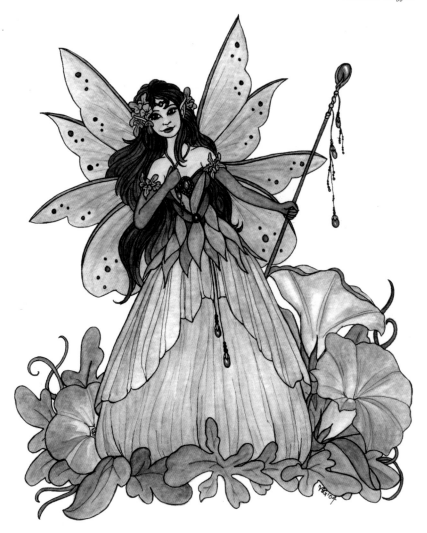

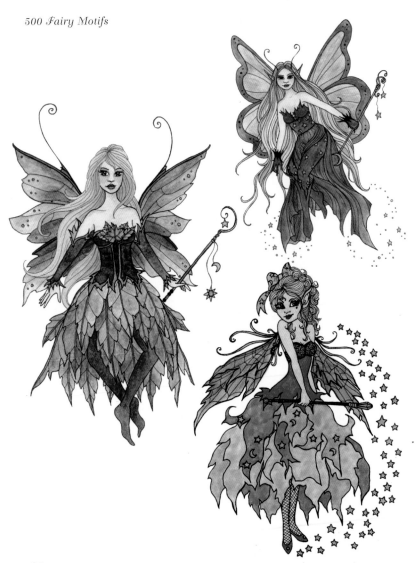

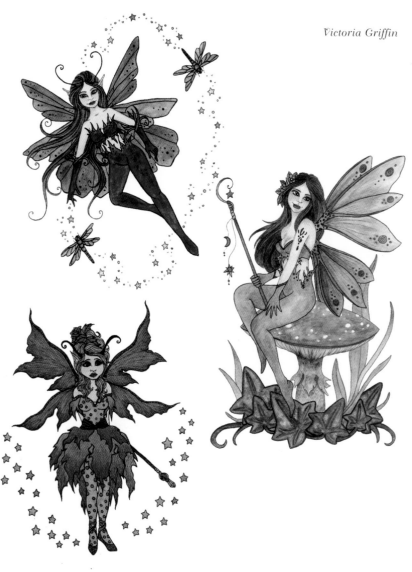

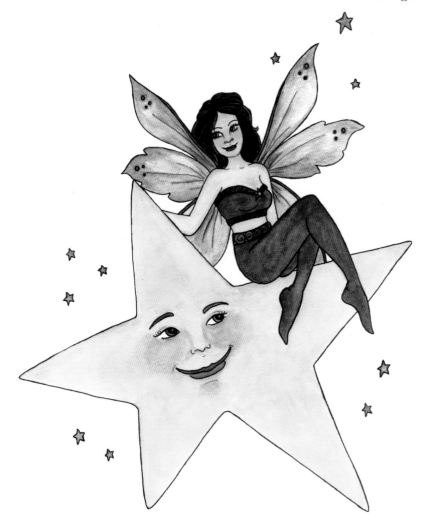

SUZANNE GYSEMAN

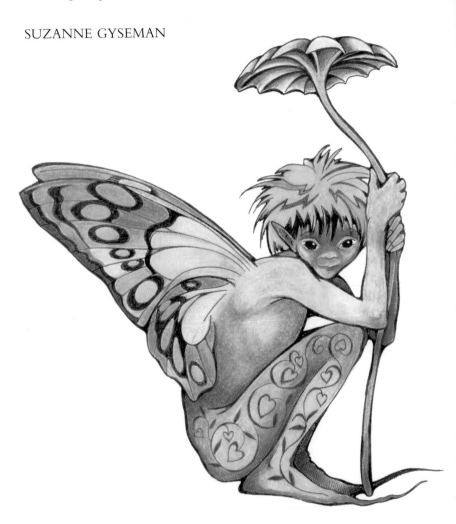

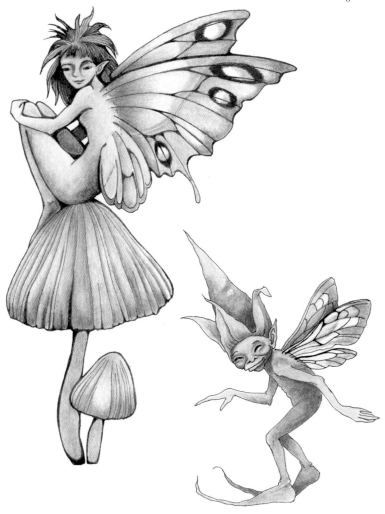

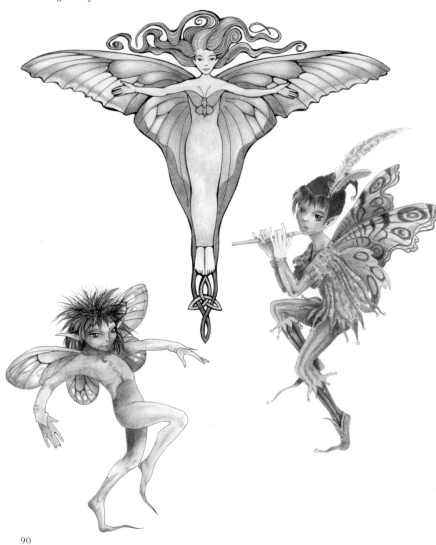

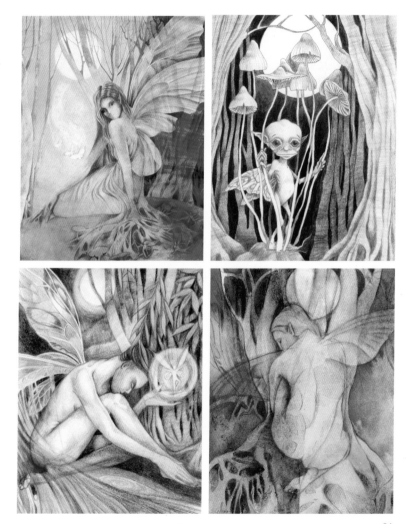

CARRIE HAWKS

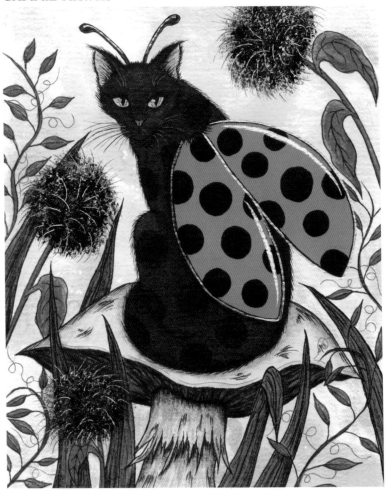

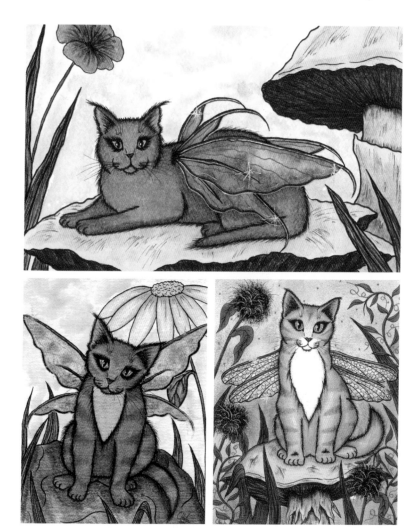

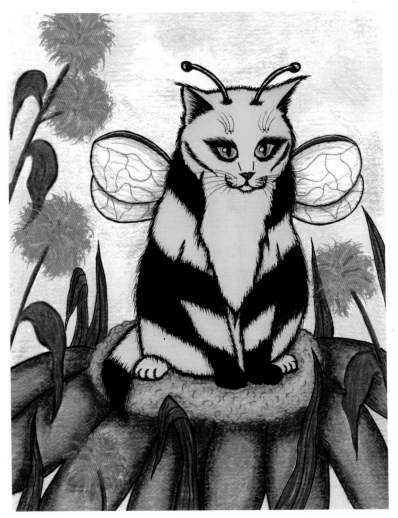

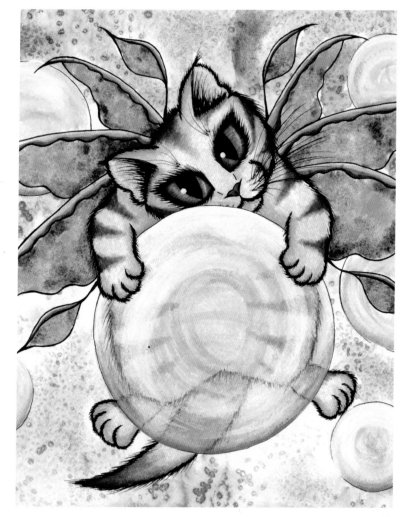

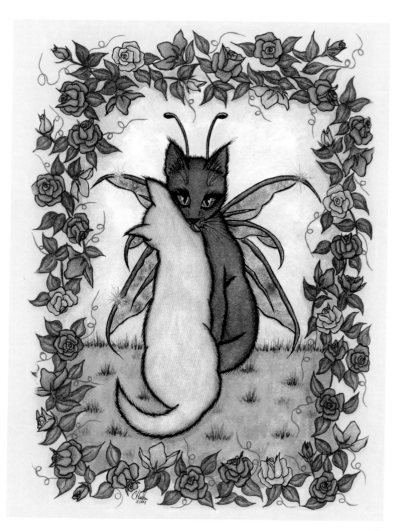

ED HICKS

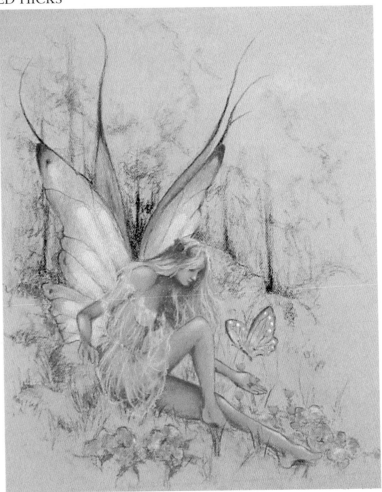

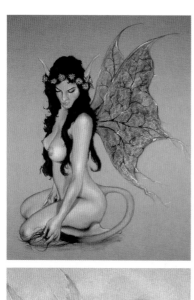

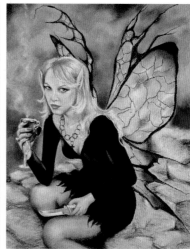

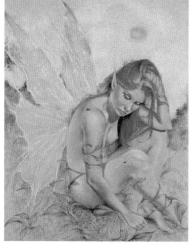

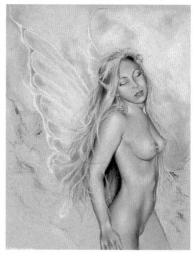

JURI IIDA

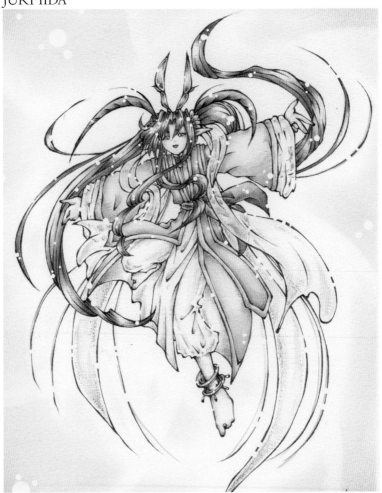

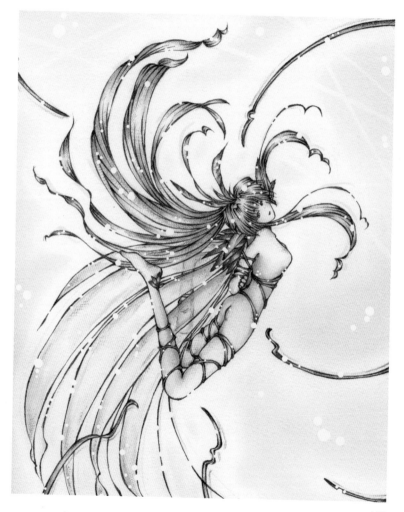

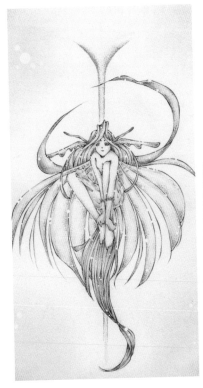

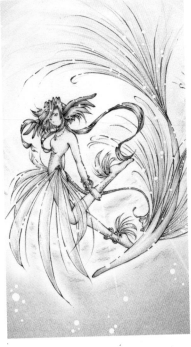

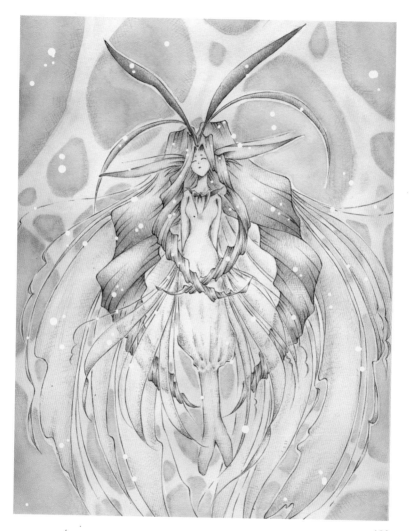

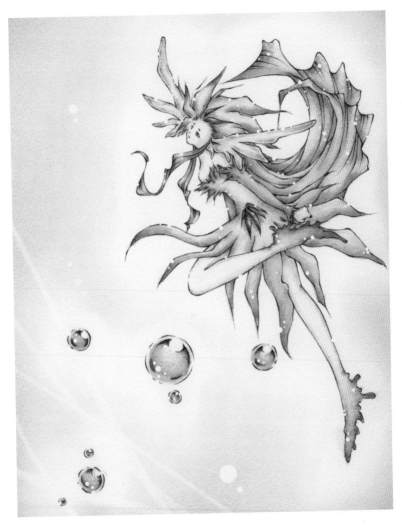

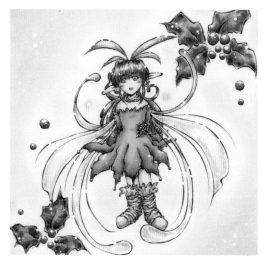

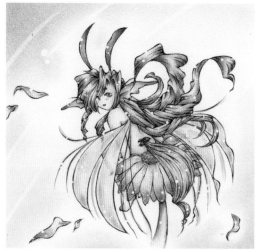

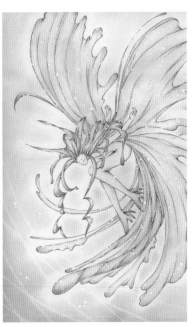

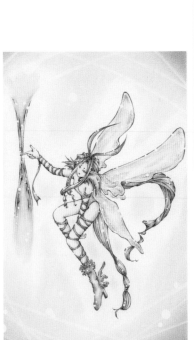

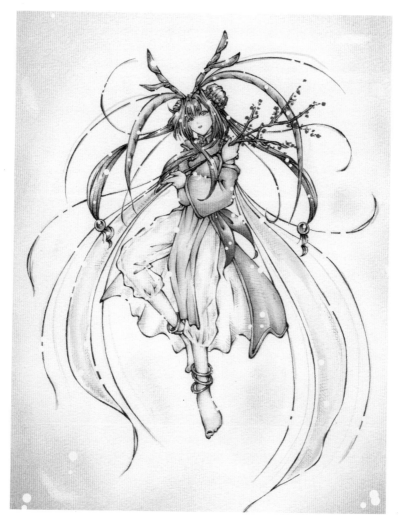

WENDY KATHLEEN

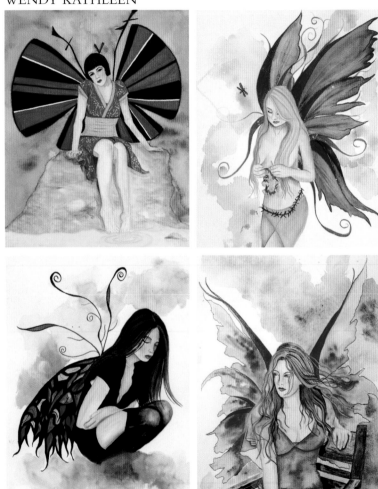

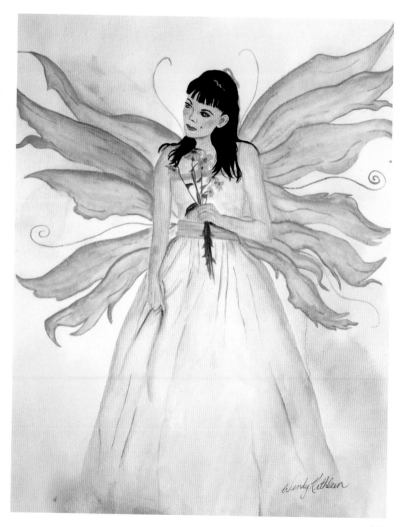

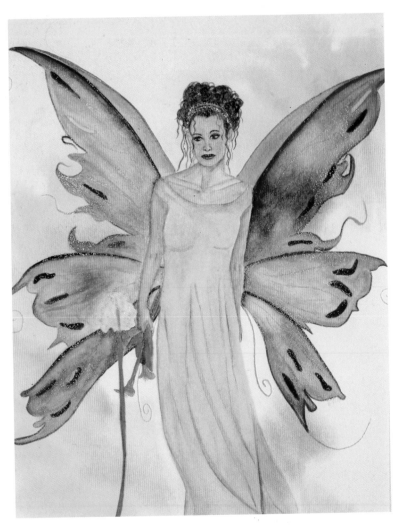

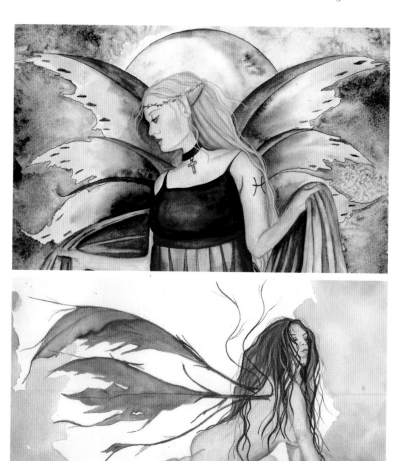

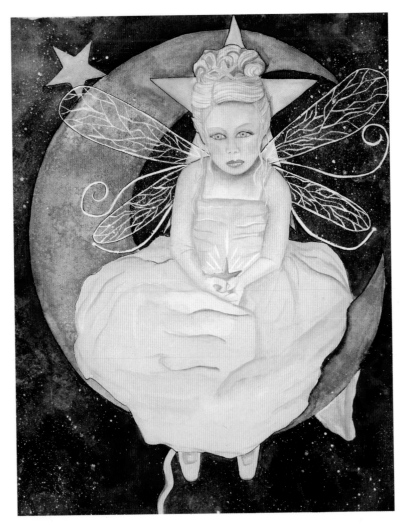

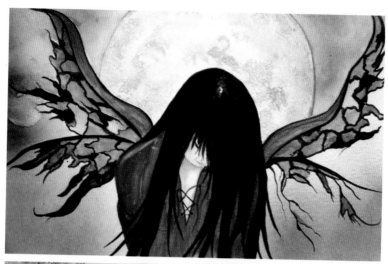

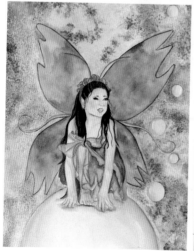

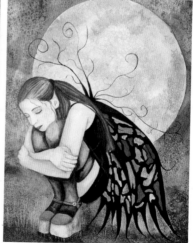

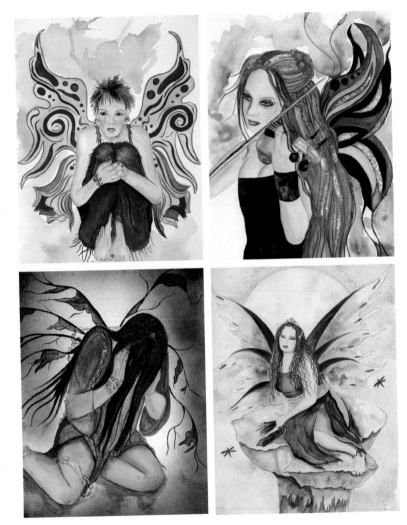

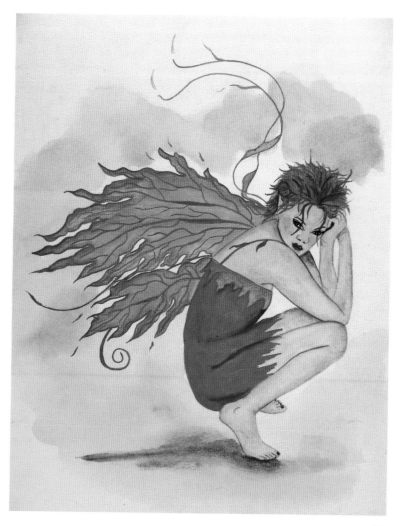

TIMOTHY KOBS

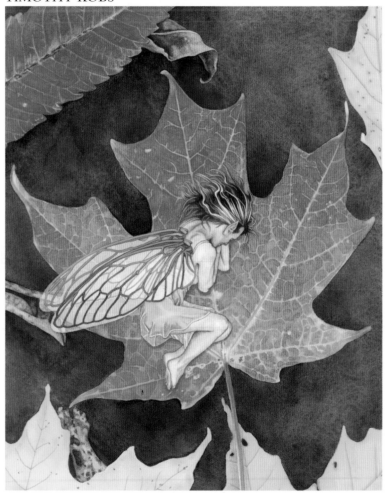

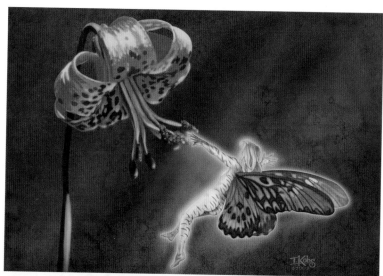

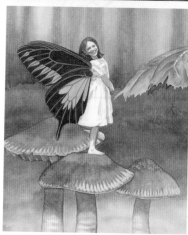
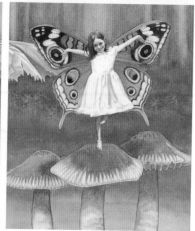

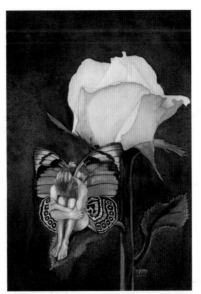

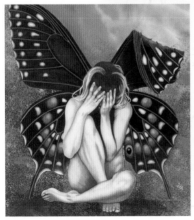

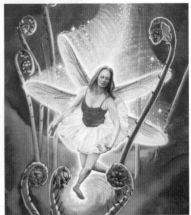

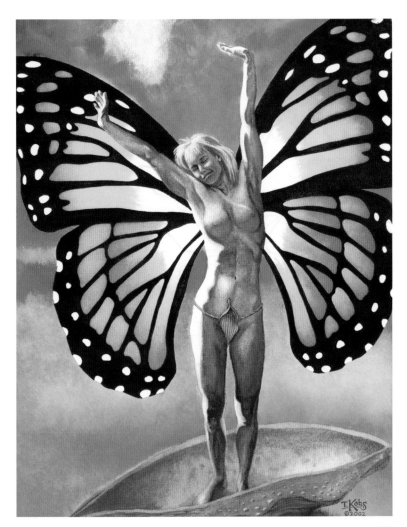

ERIN MINCKS

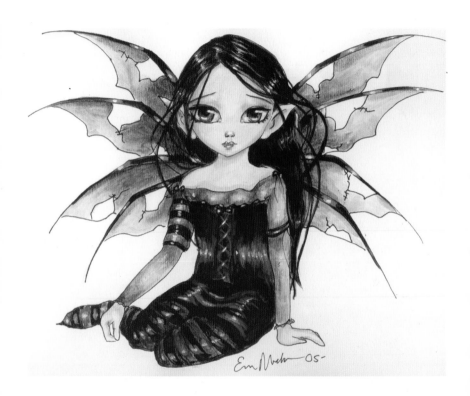

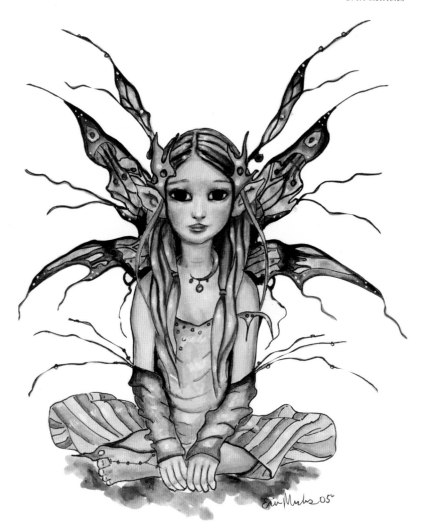

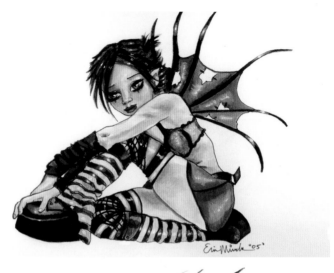

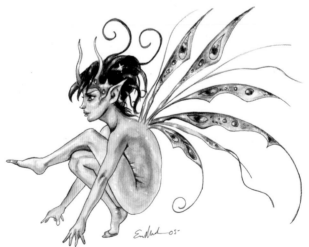

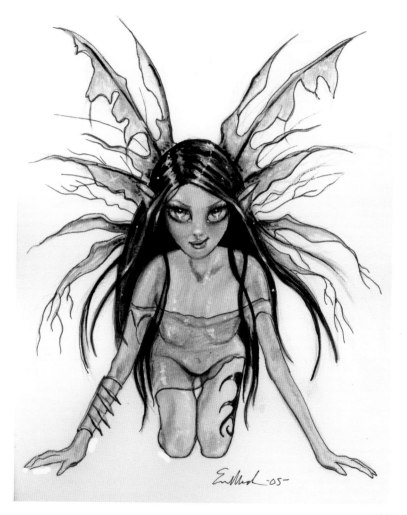

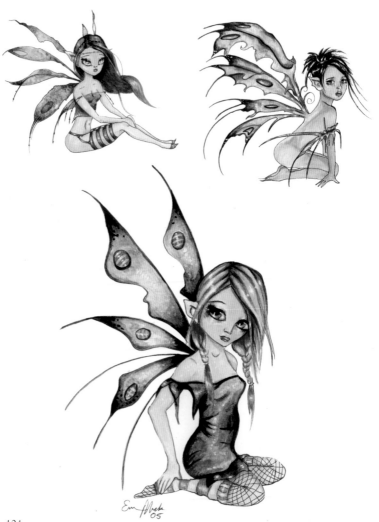

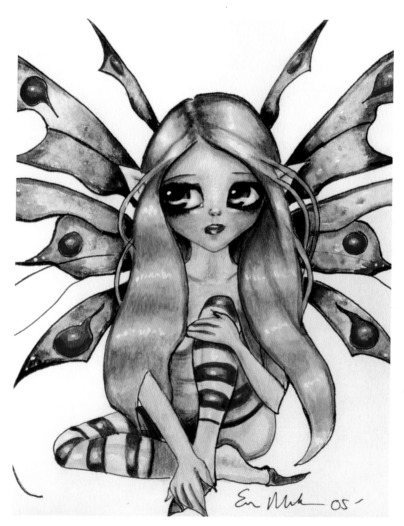

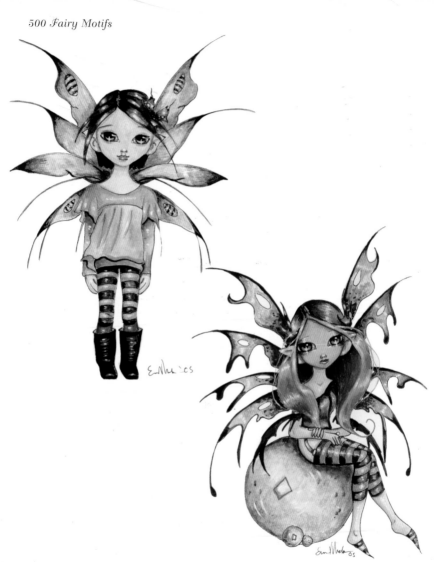

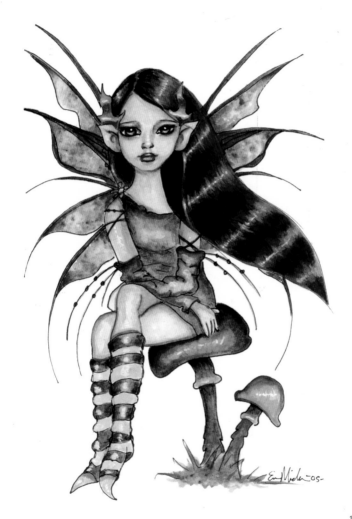

KAREN MILES

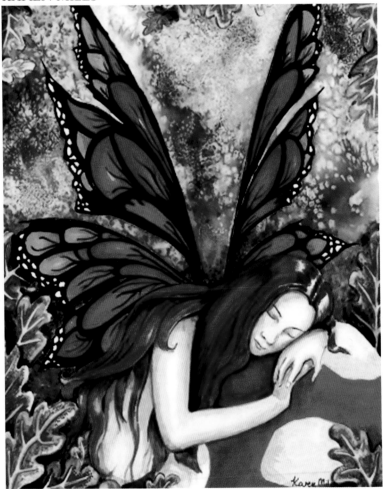

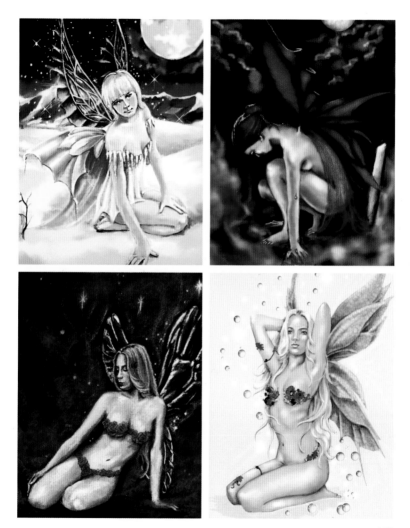

SARAH PAULINE

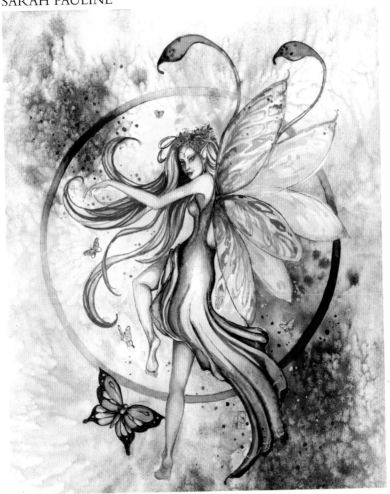

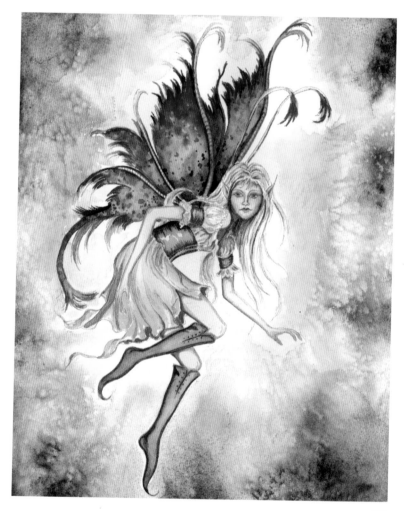

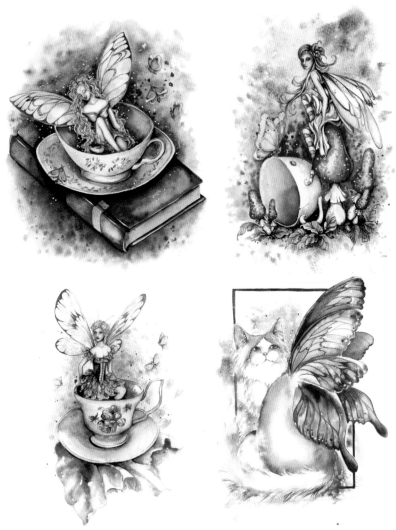

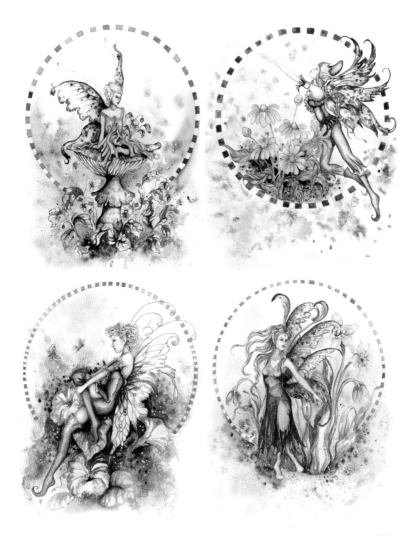

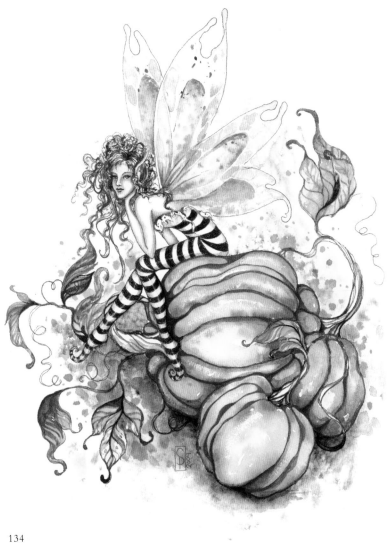

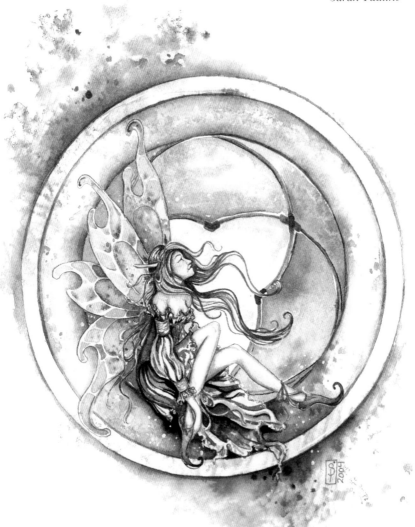

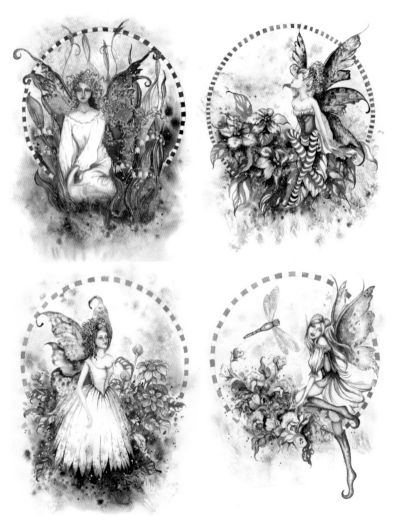

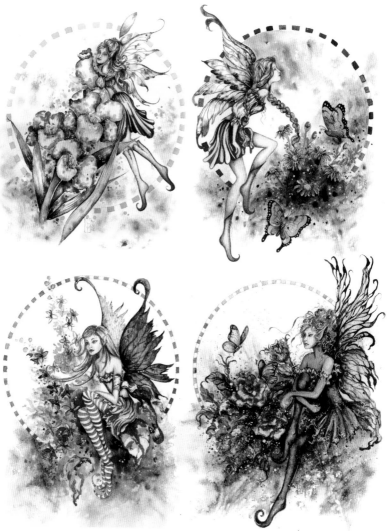

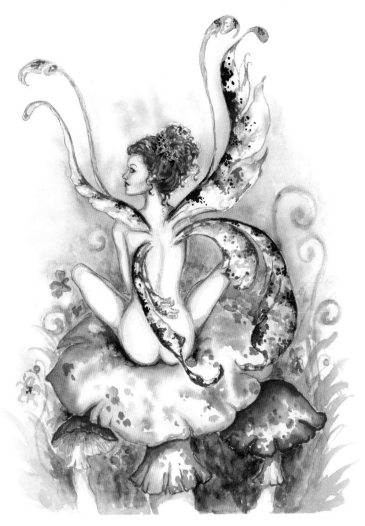

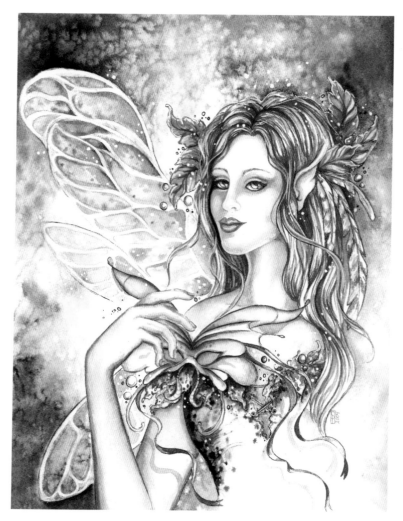

NATALIA PIERANDREI

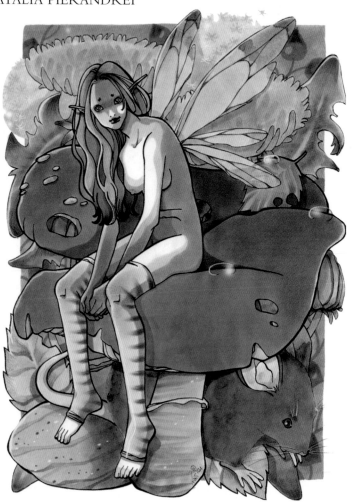

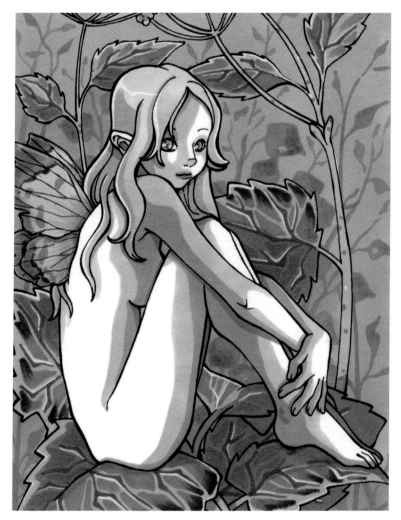

NICOLE PISANIELLO

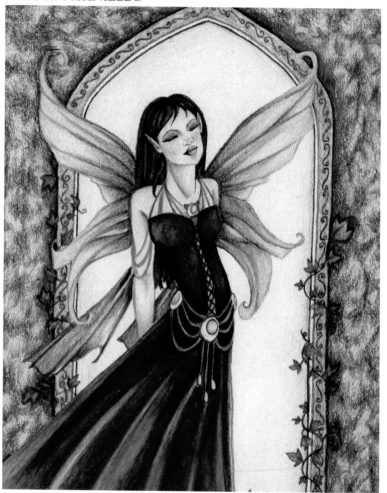

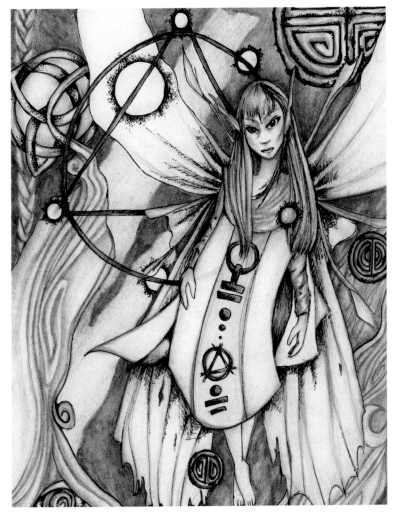

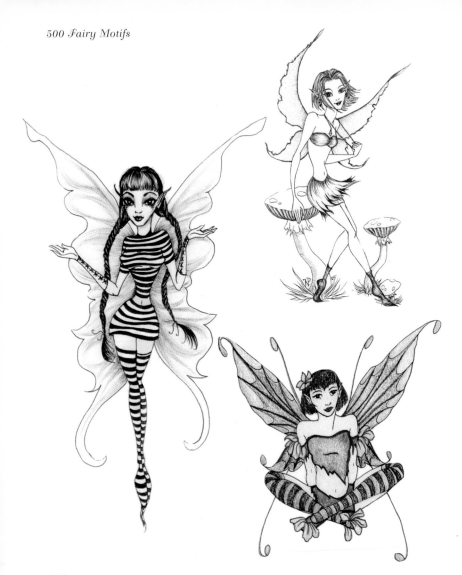

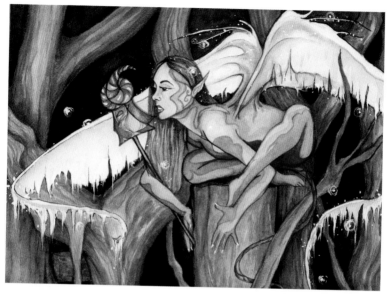

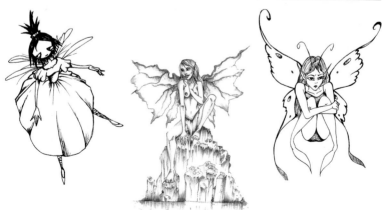

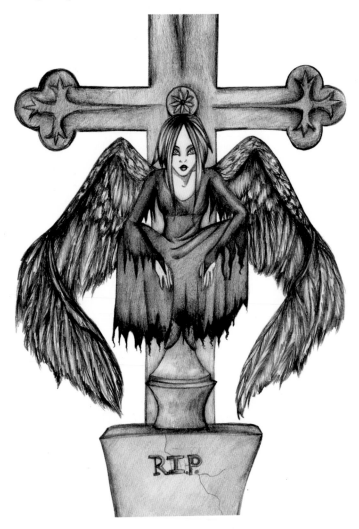

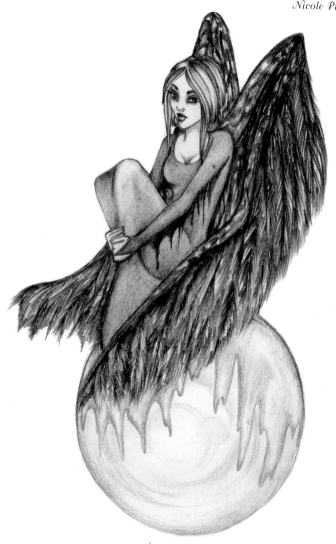

LINDA RAVENSCROFT

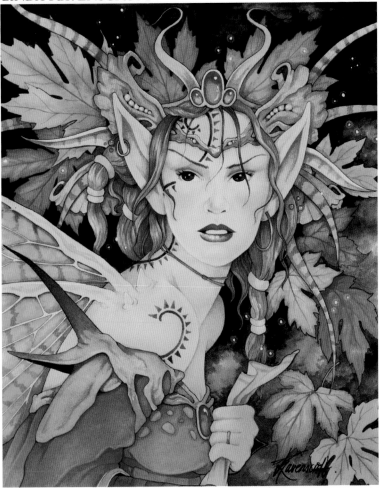

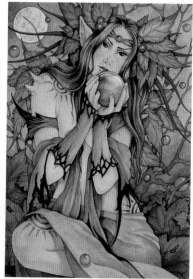

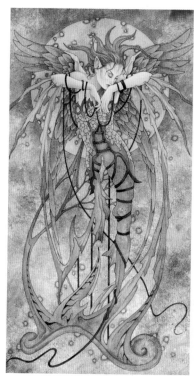

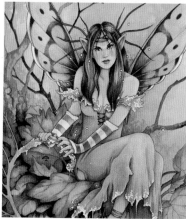

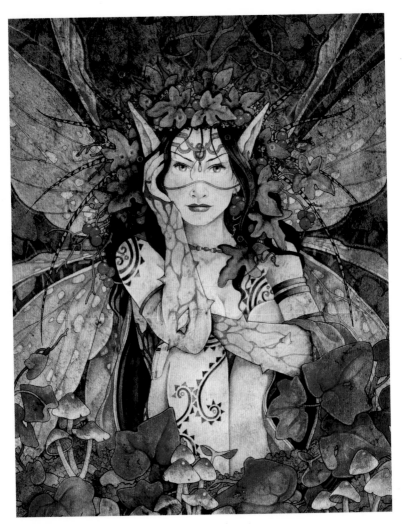

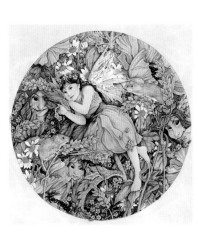

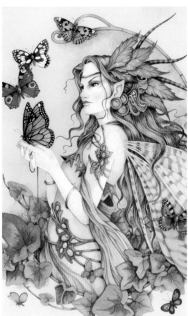

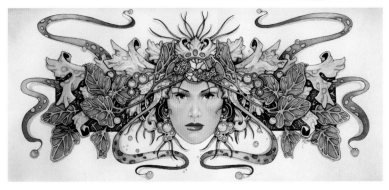

AIMEE RAY

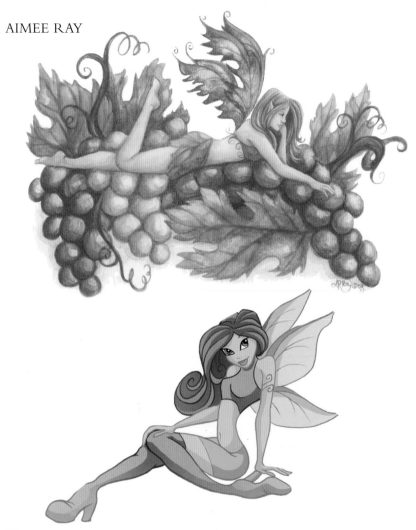

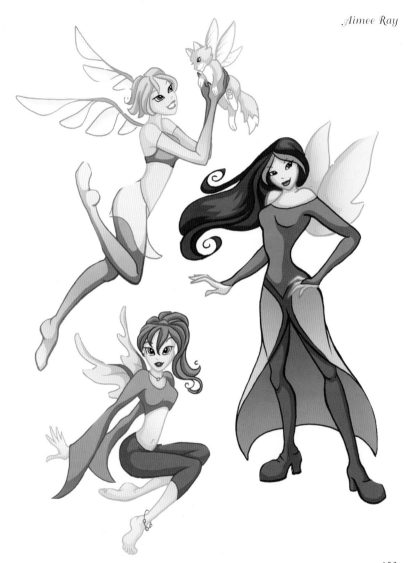

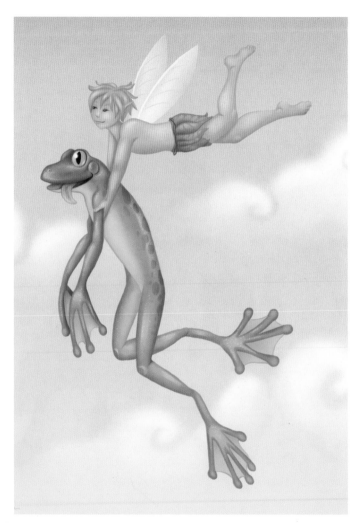

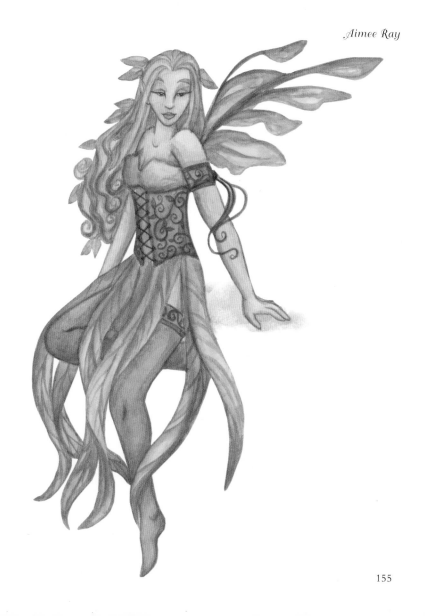

SUZANNE RICHARDS

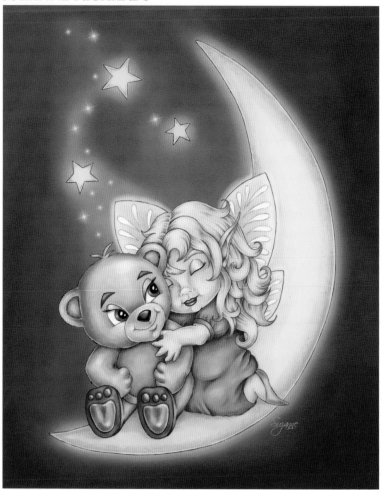

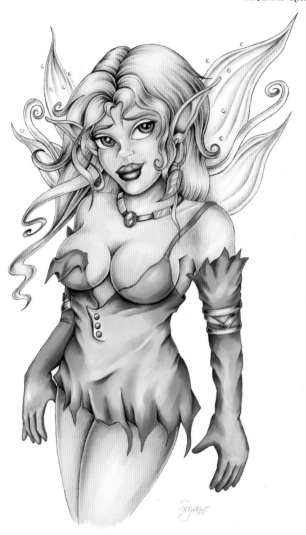

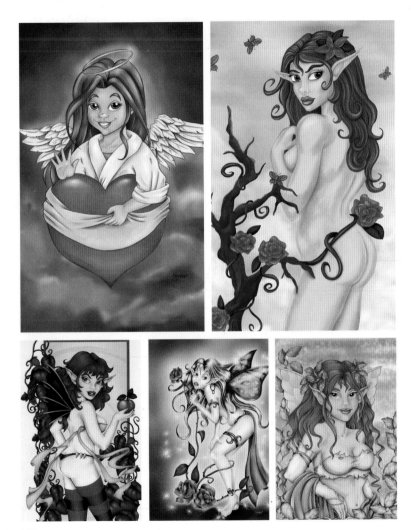

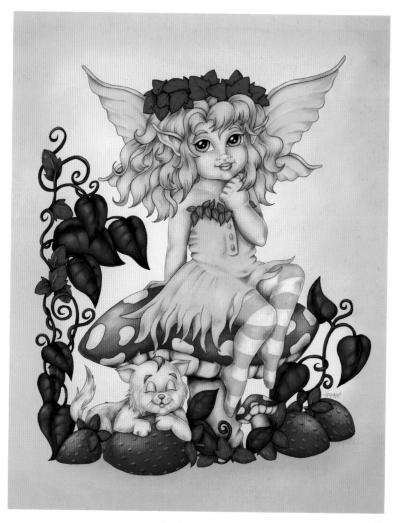

SHANO

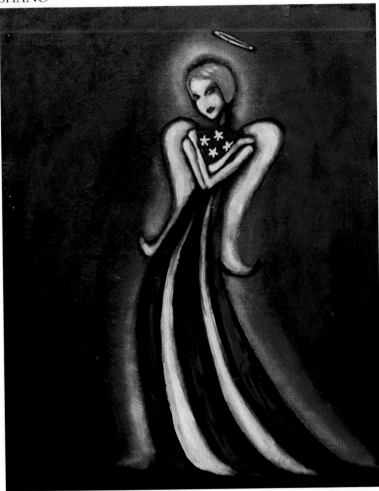

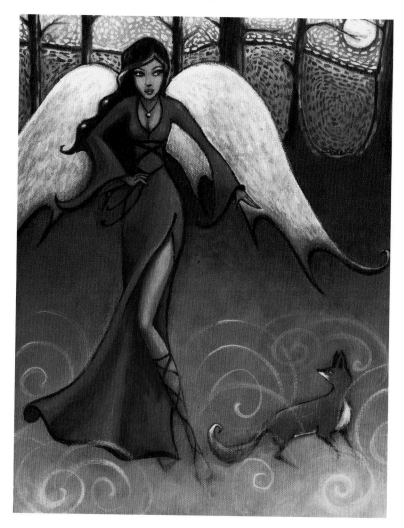

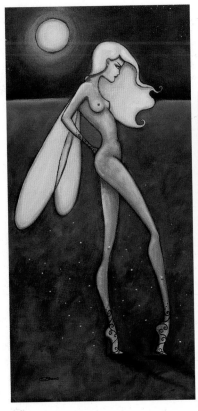

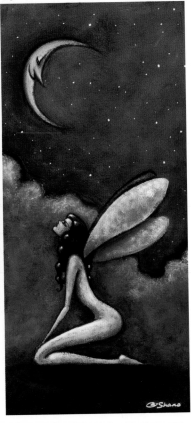

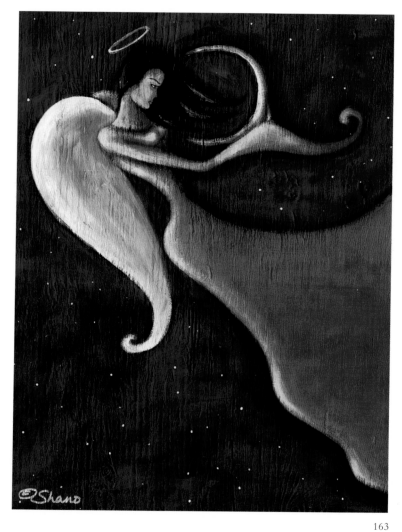

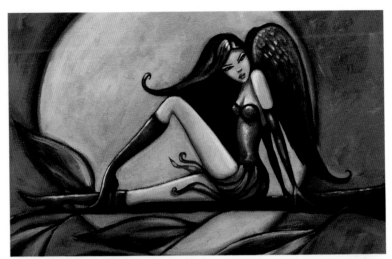

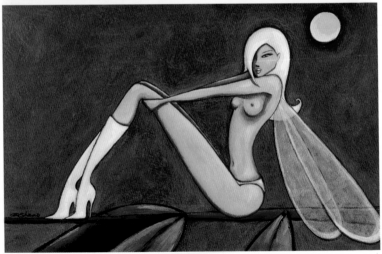

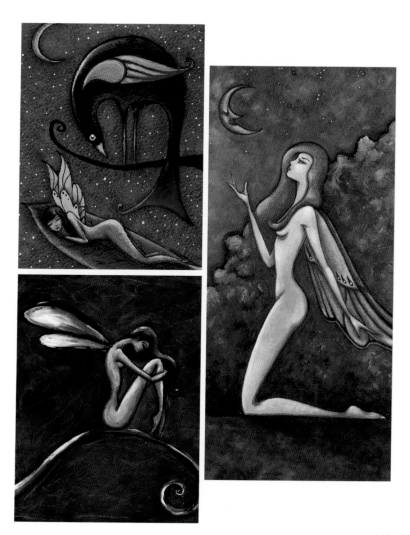

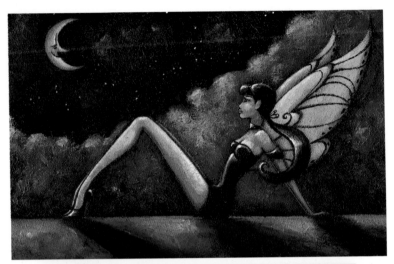

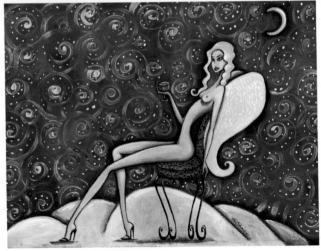

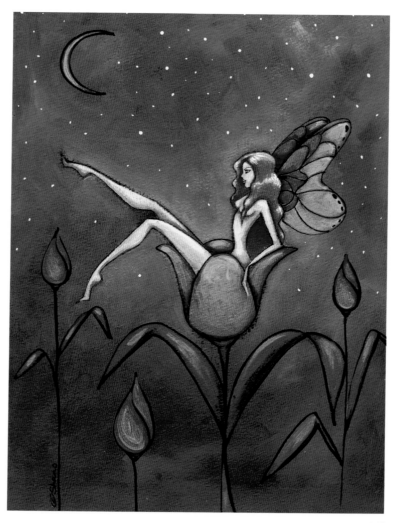

ANN MARI SJÖGREN

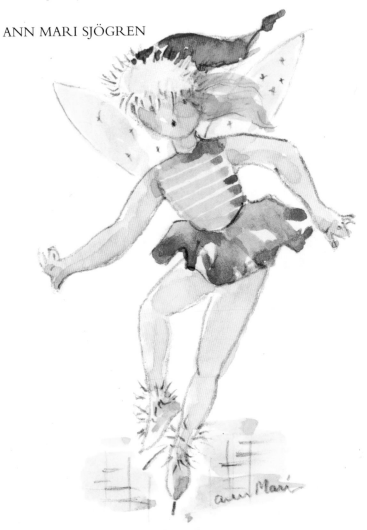

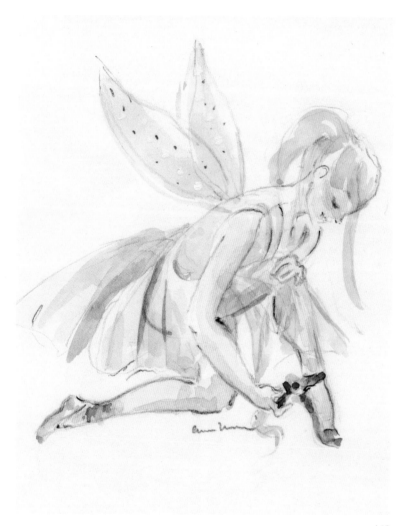

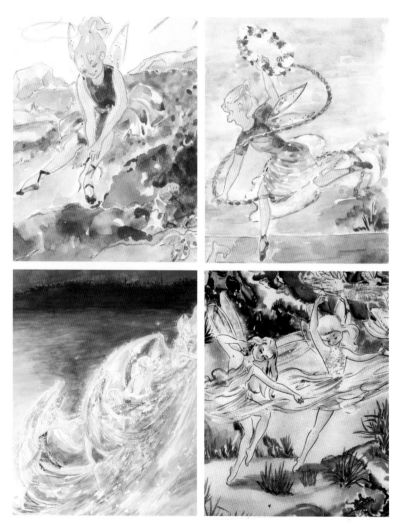

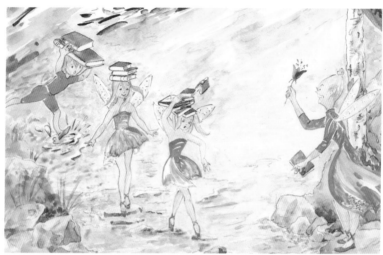

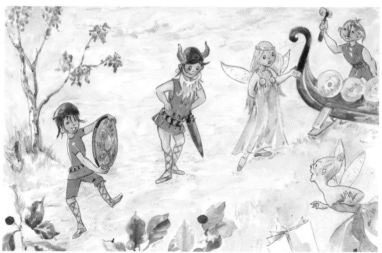

TERRELL SMITH-DORFEO

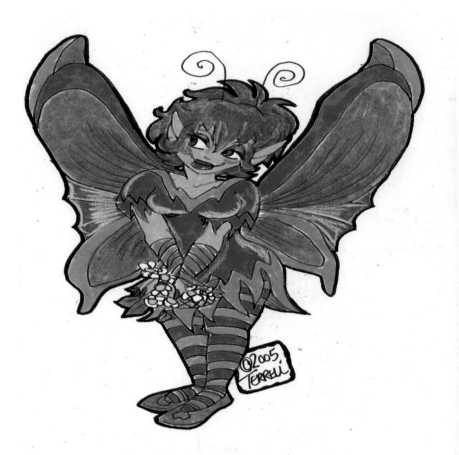

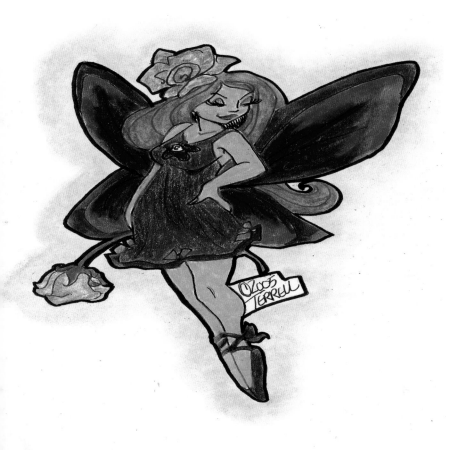

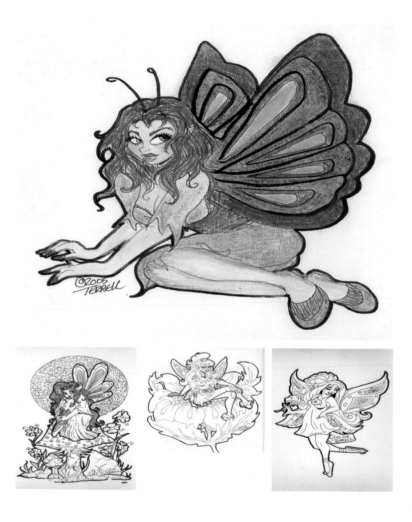

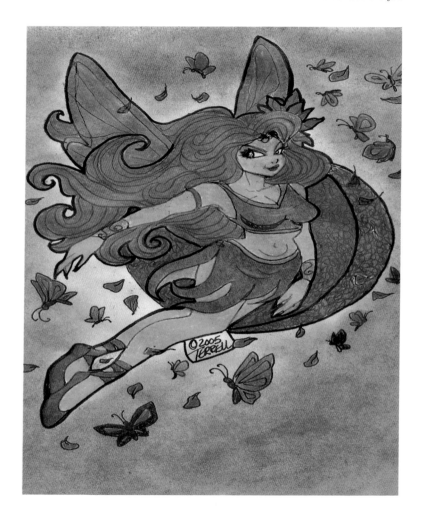

PAULINA STUCKEY-CASSIDY

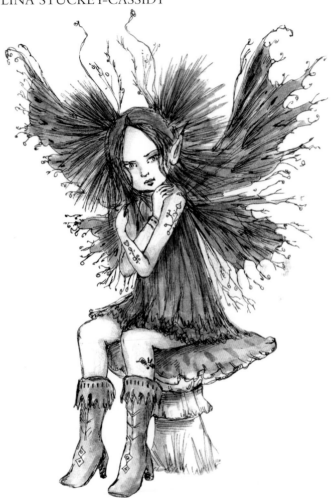

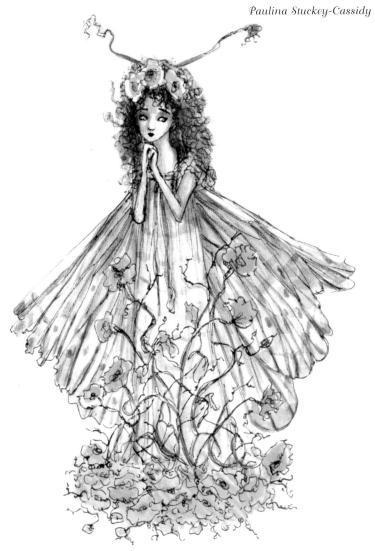

177

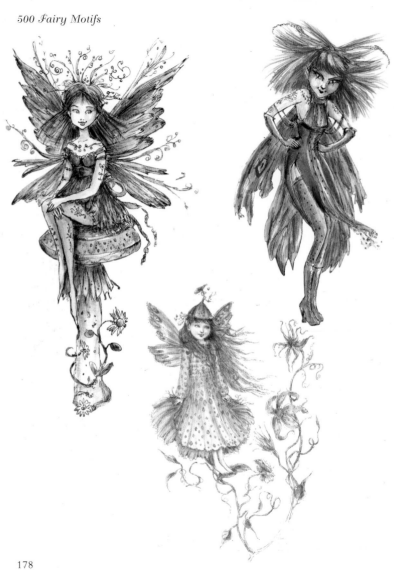

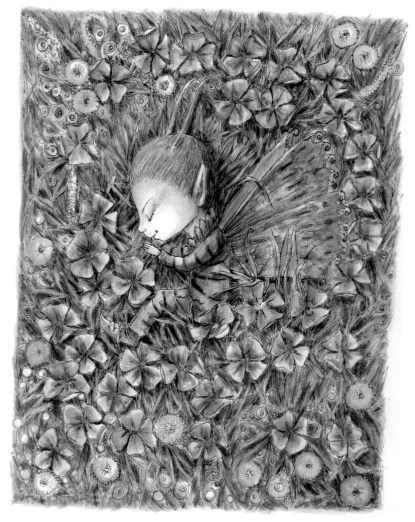

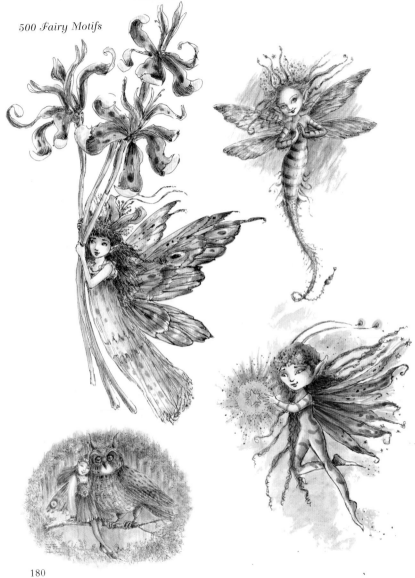

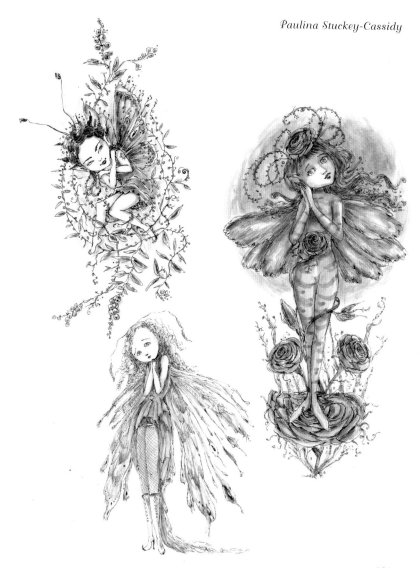

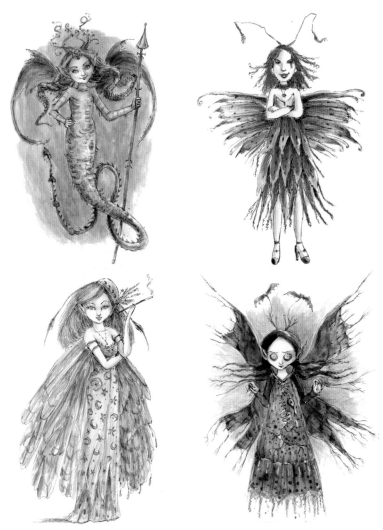

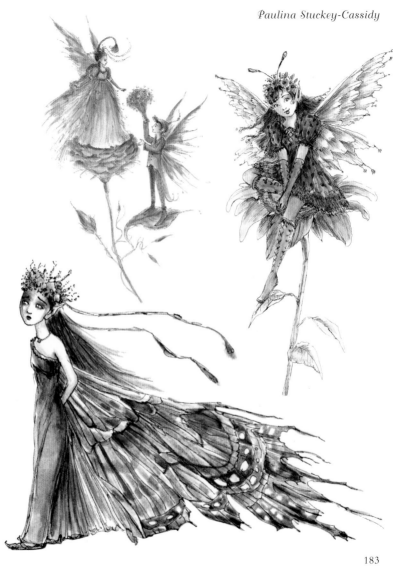

RYU TAKEUCHI

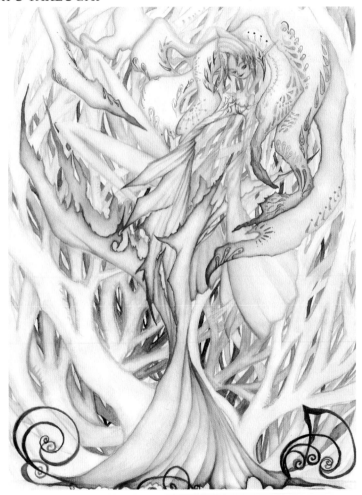

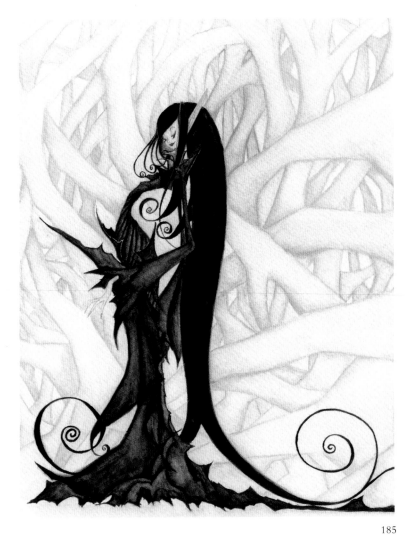

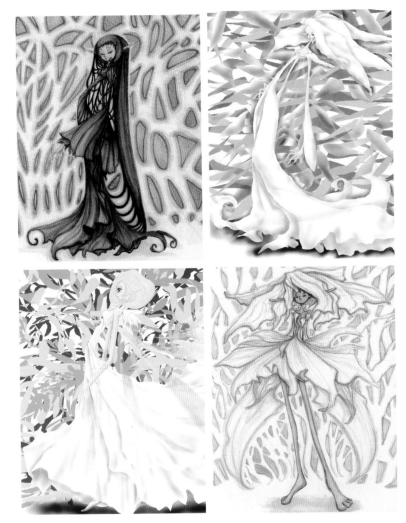

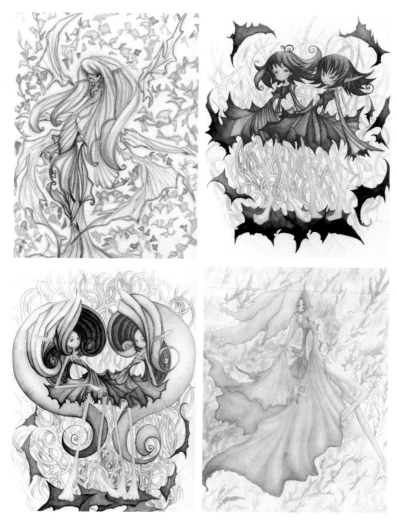

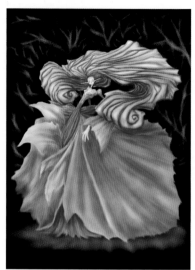

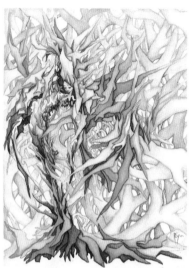

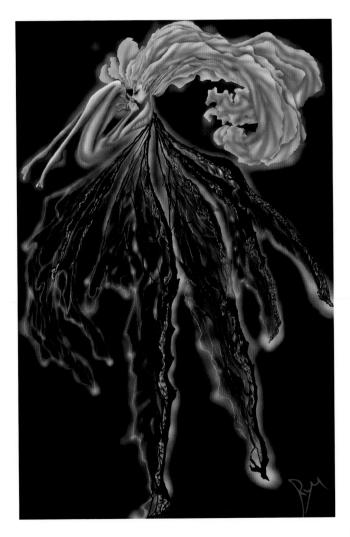

MELISSA VALDEZ

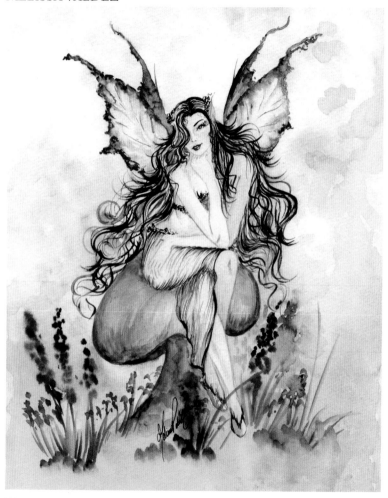

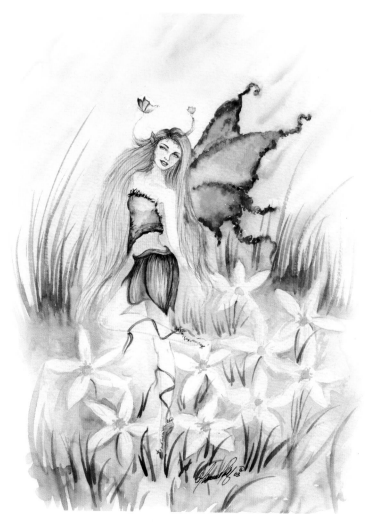

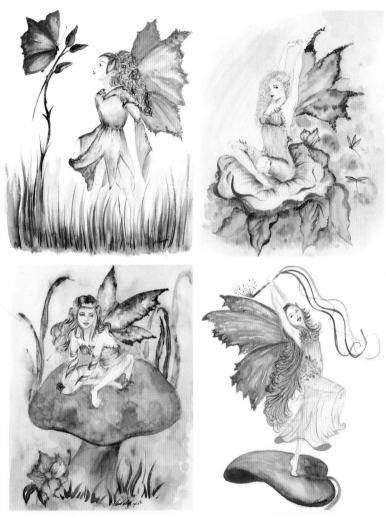

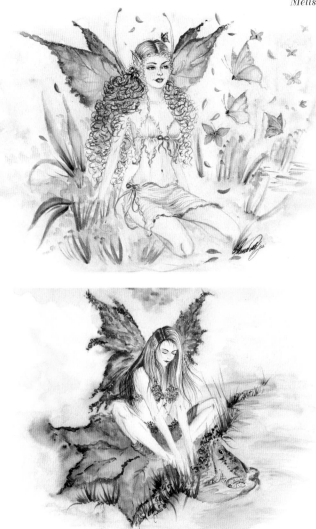

193

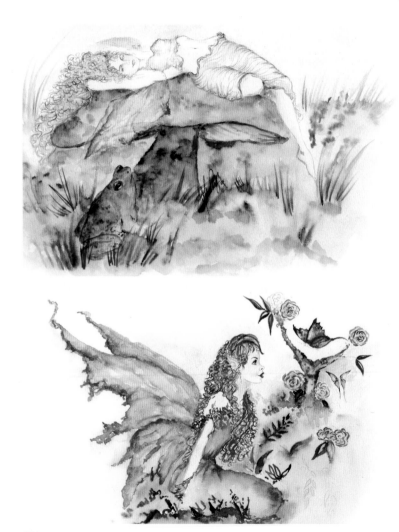

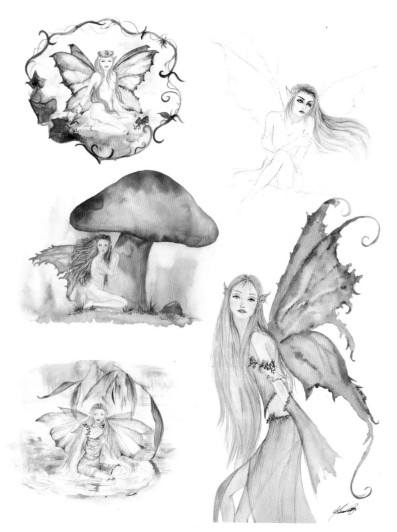

LINDA VAROS

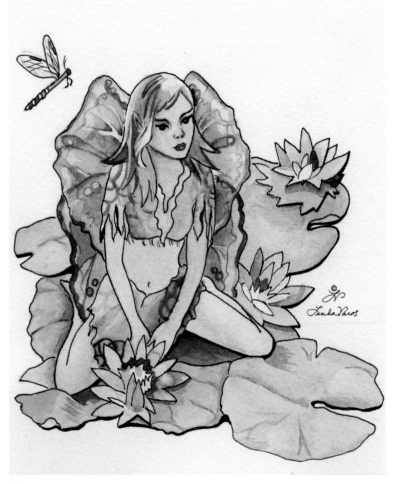

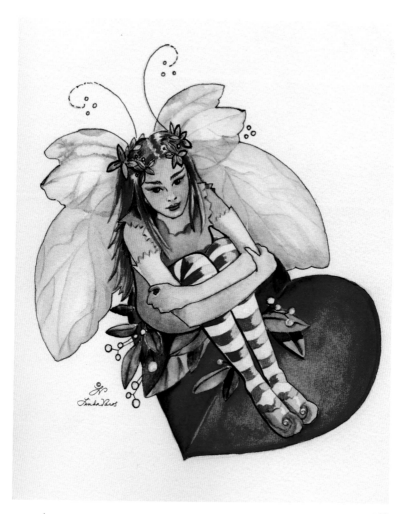

MARIA WILLIAM

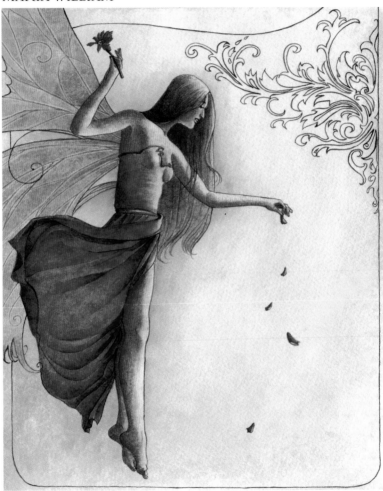

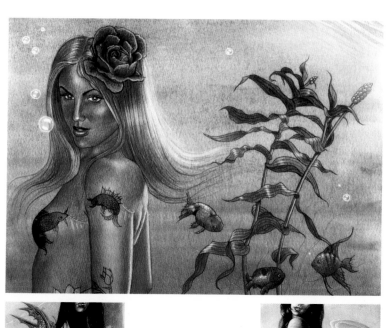

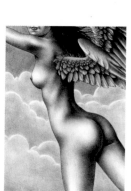
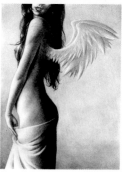

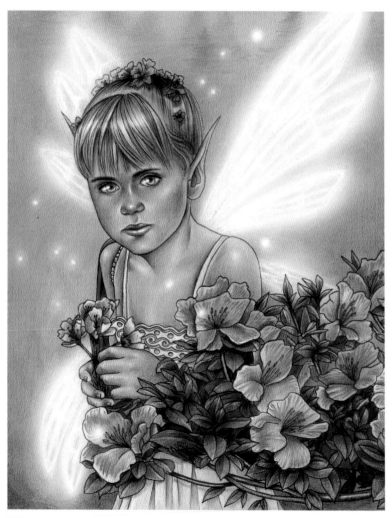

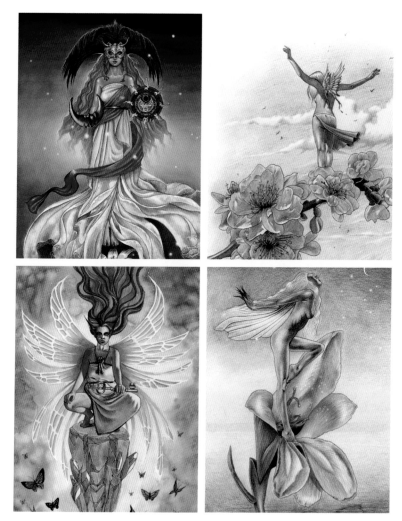

MARIA VAN BRUGGEN

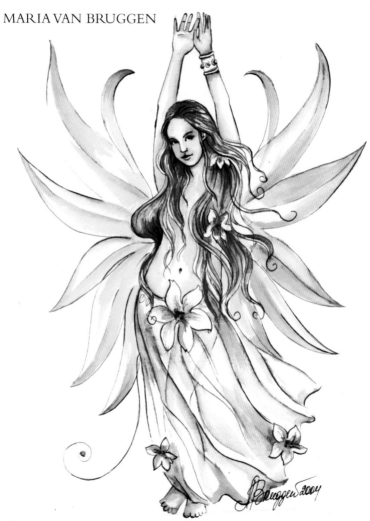

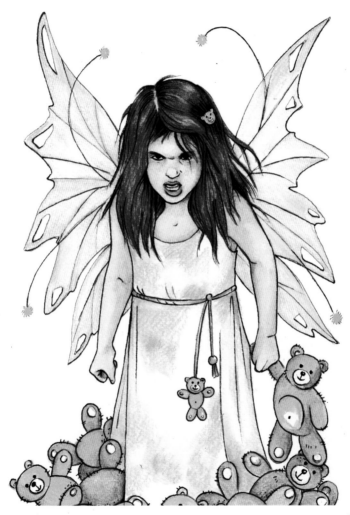

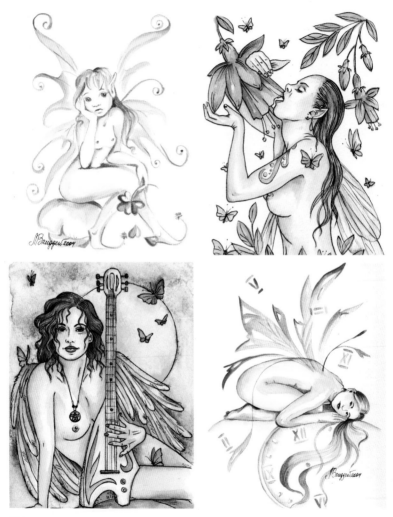

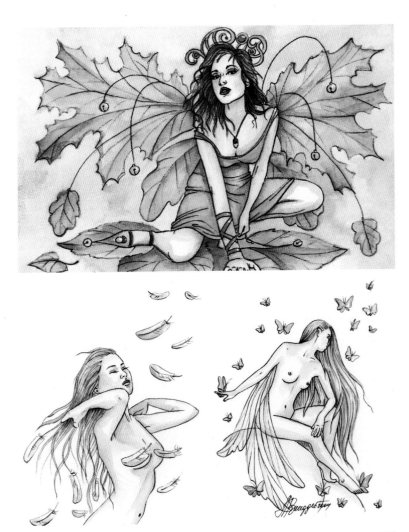

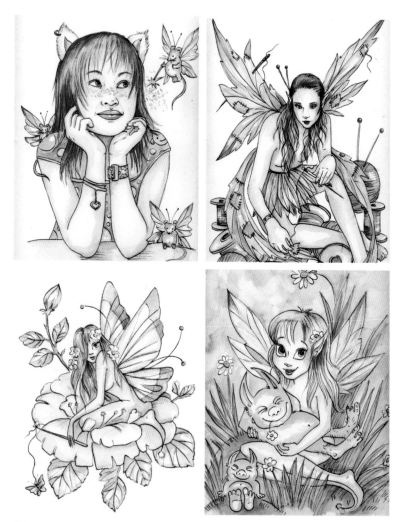

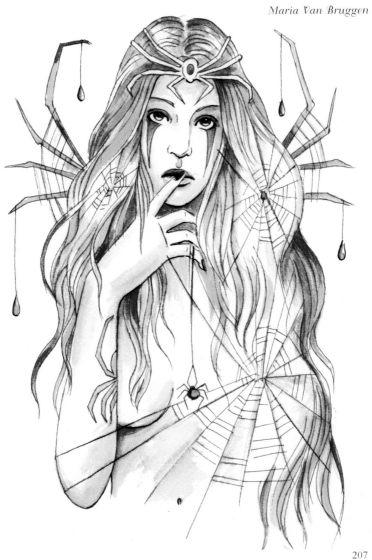

BARBARA YOCHUM

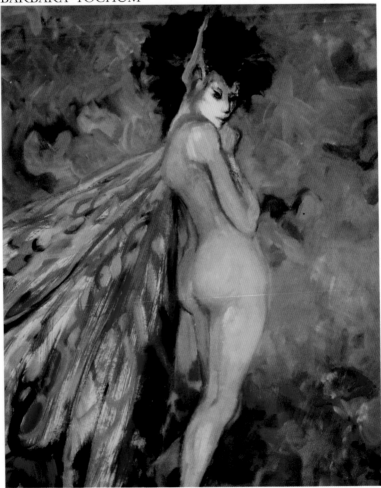

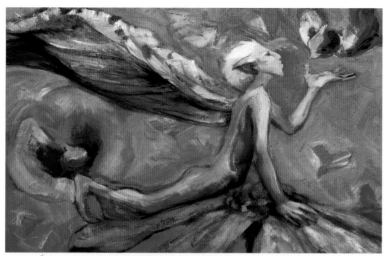

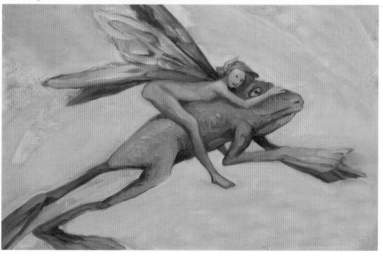

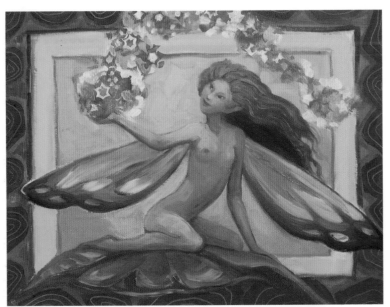

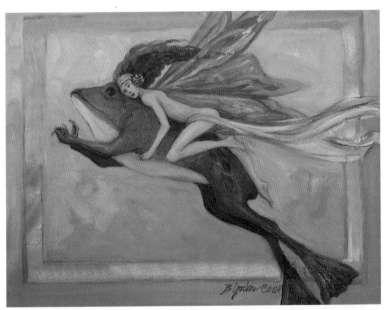

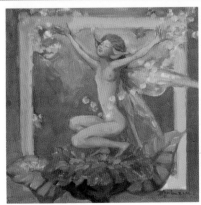

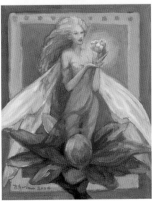

JOHN RANDALL YORK

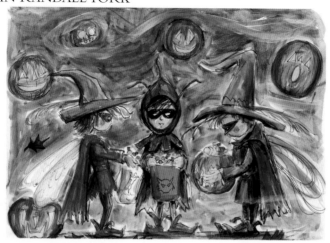

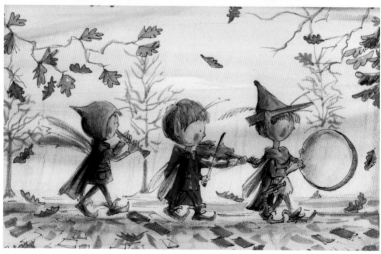

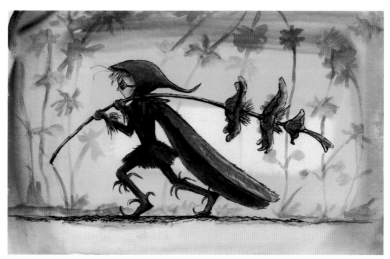

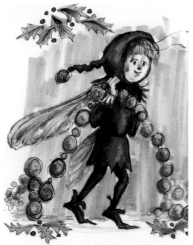

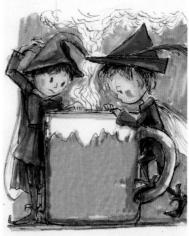

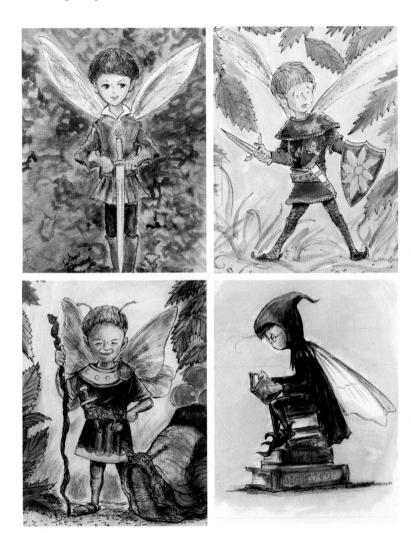

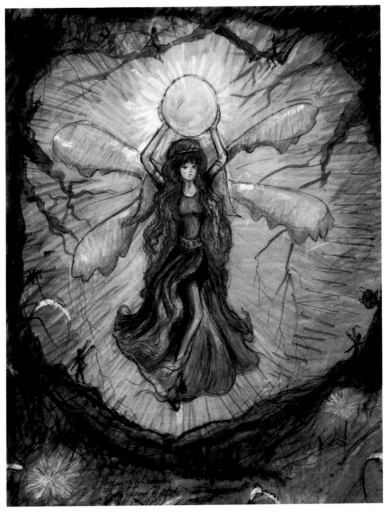

COLEEN MCINTYRE

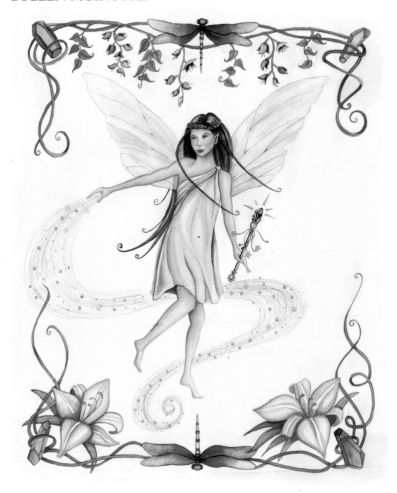

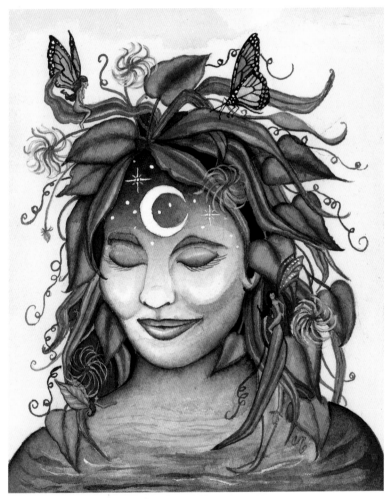

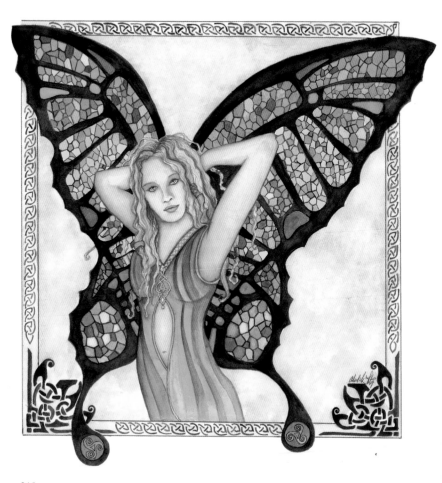

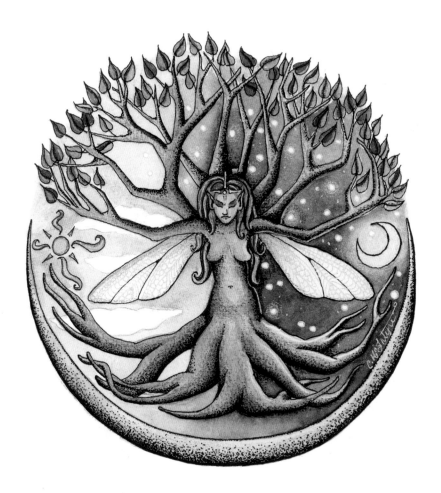

SILVIA LUGLI

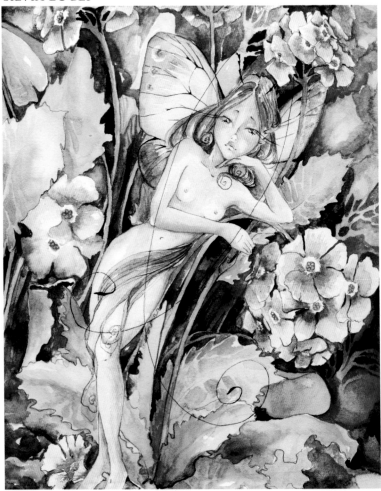

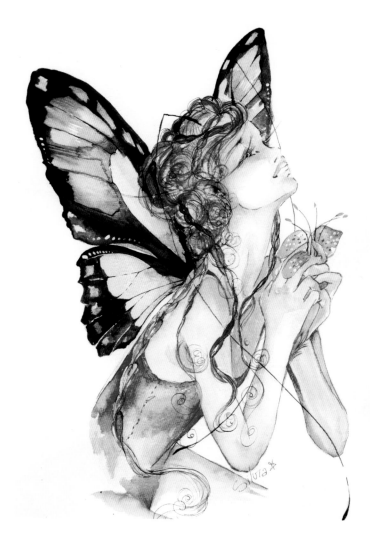

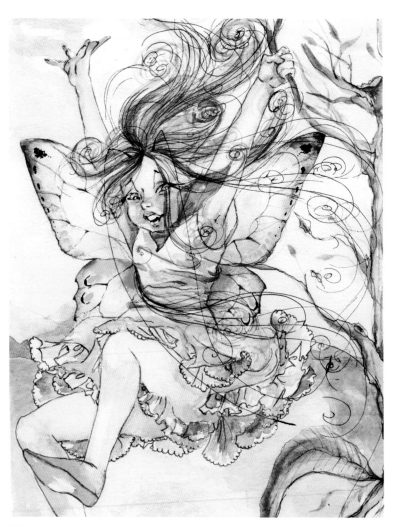

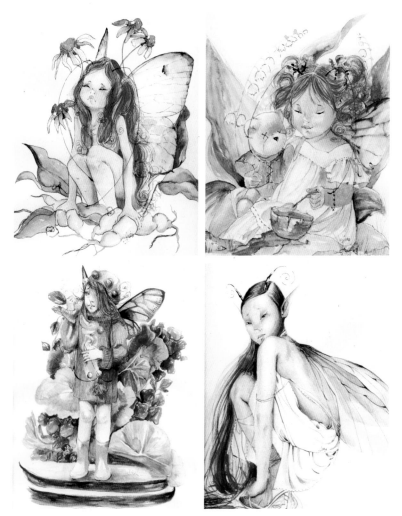

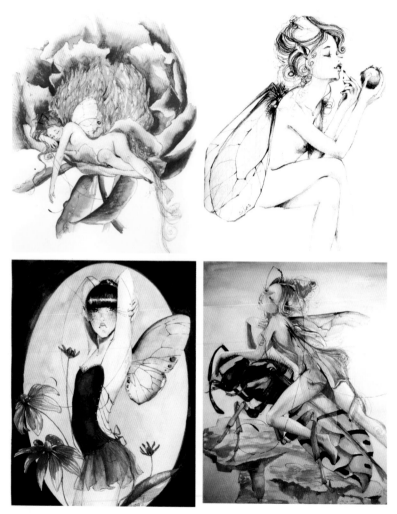

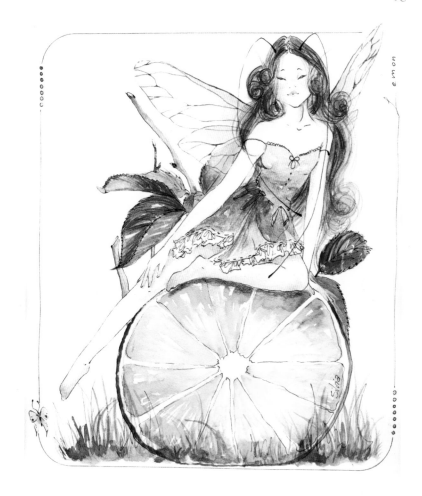

SUSAN MILLER

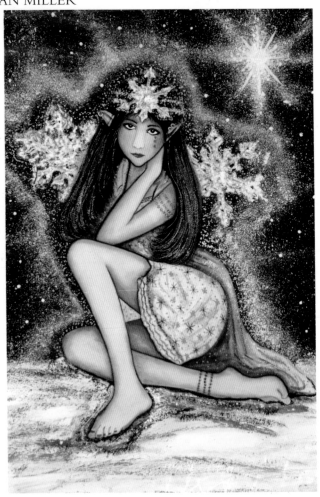

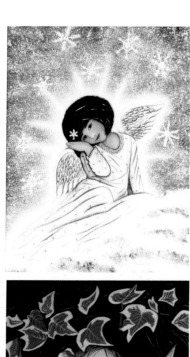

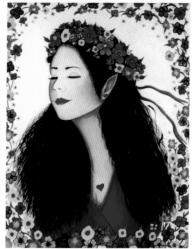

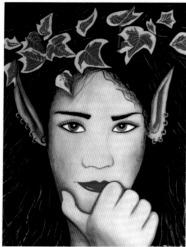

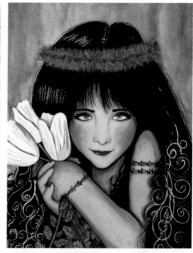

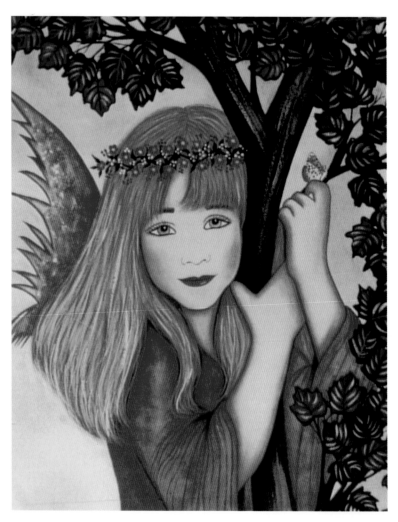

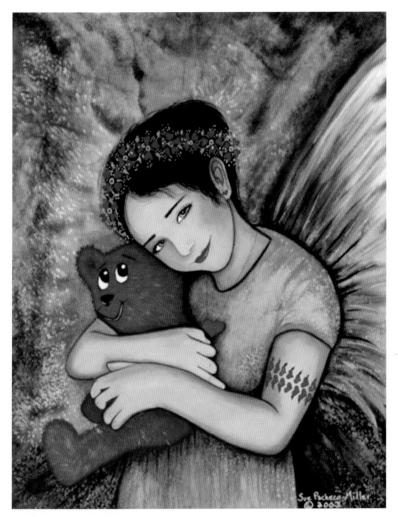

STATHIS KARABATEAS

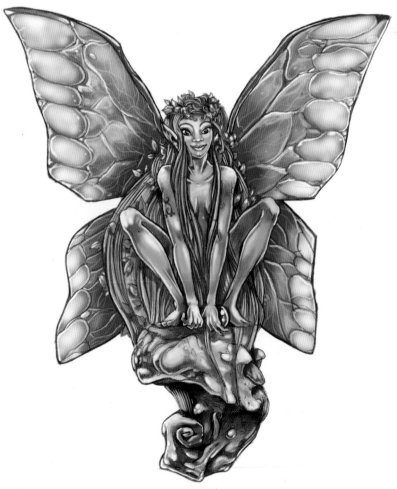

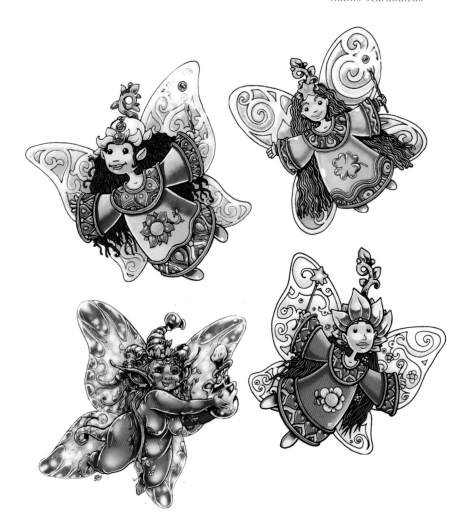

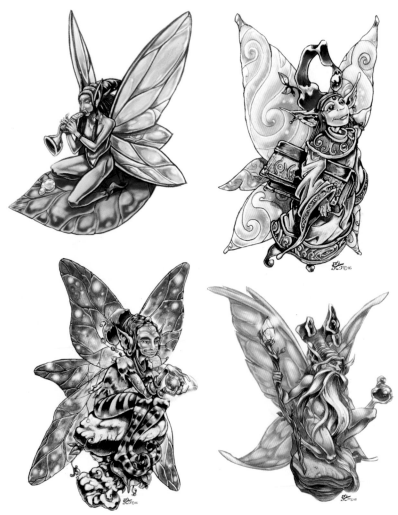

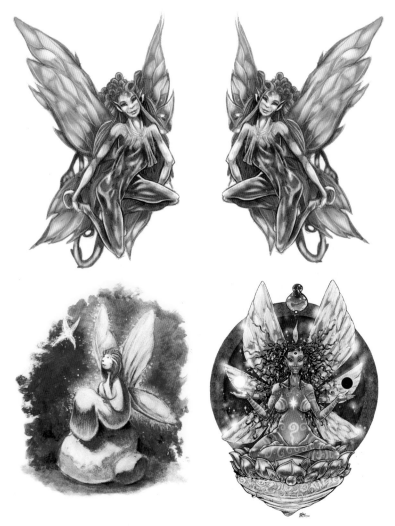

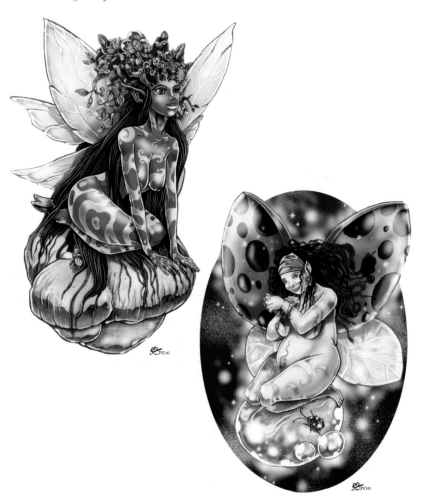

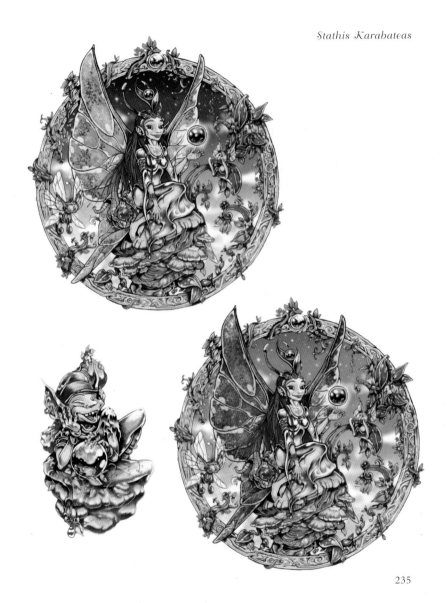

LISELOTTE ERIKSSON

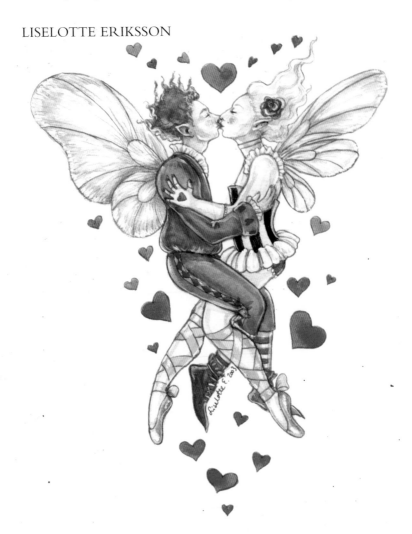

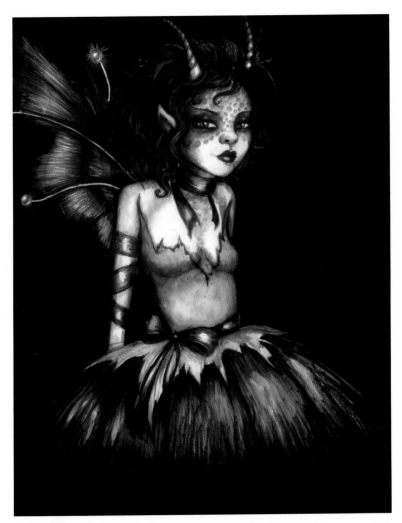

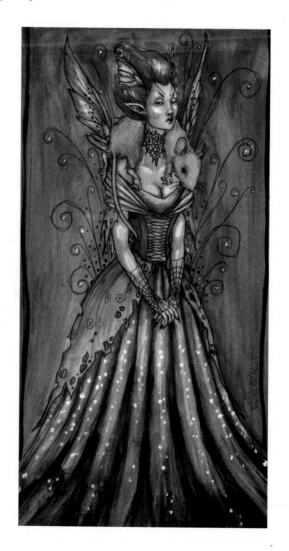

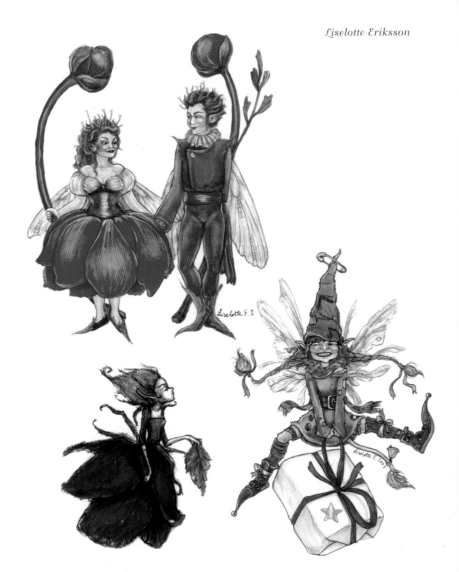

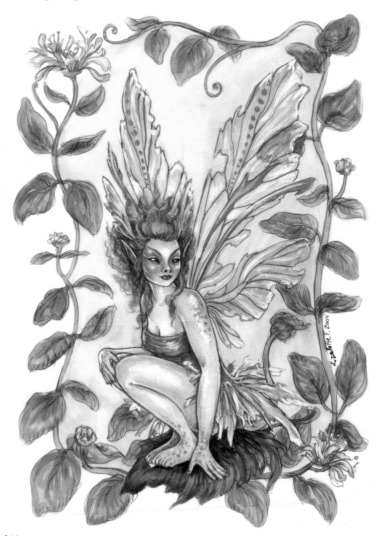

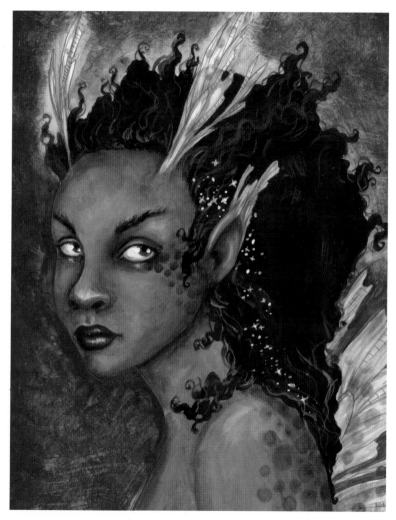

JOHN ARTHUR

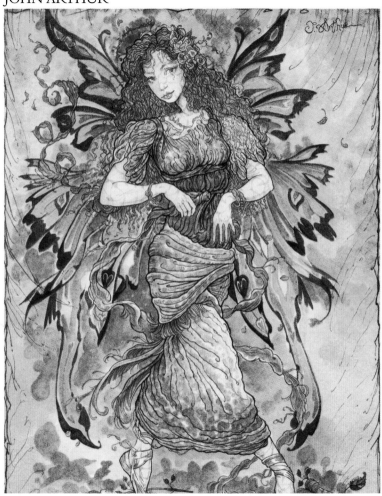

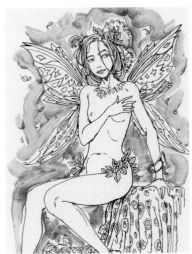
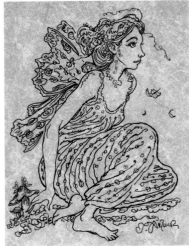
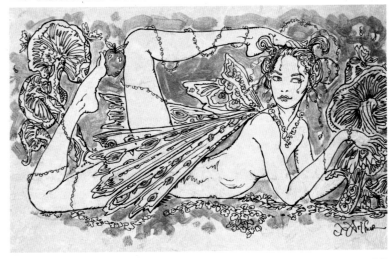

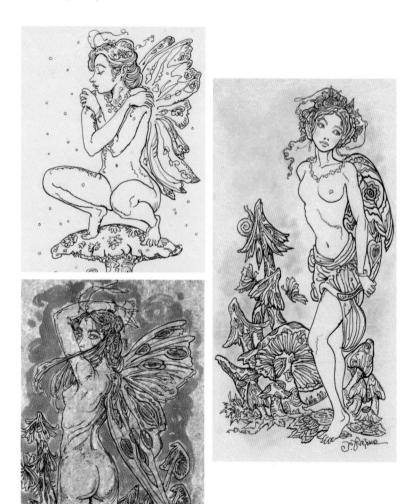

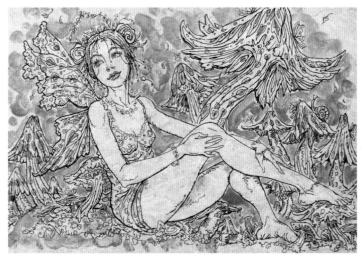

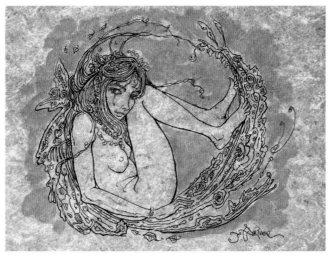

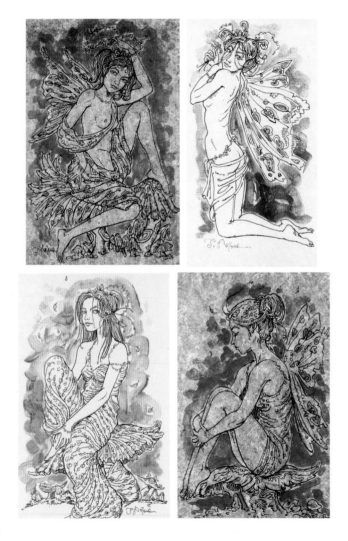

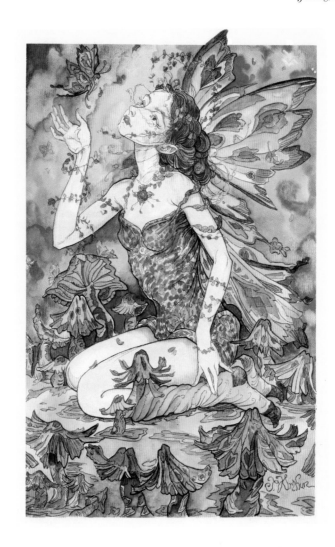

JAMES BROWNE

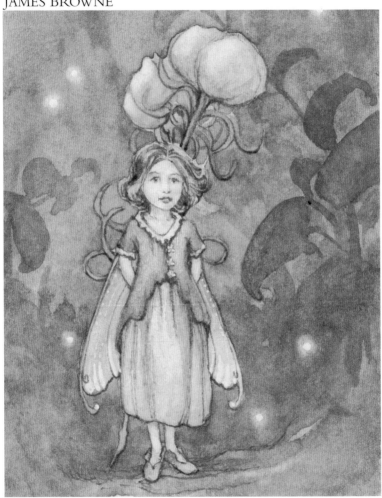

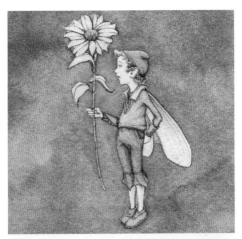

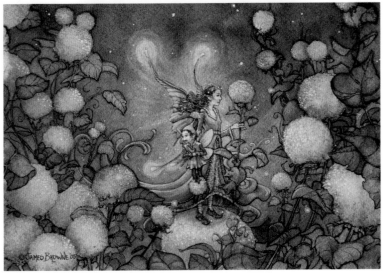

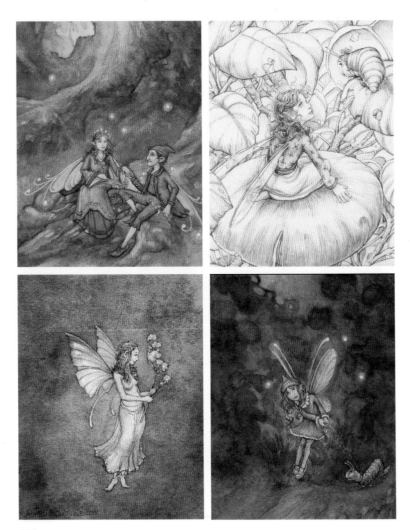

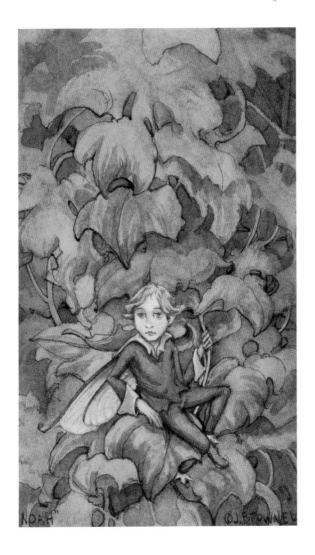

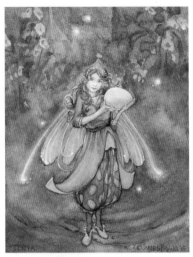

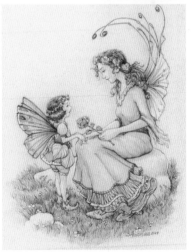

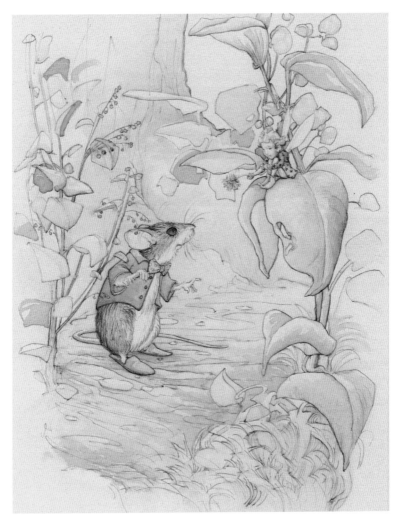

Author Acknowledgements

Special thanks to my mentor and fairy godfather whose encouragement has made this book possible for me and the artists to whom he has dedicated support in books and on the web. He is dedicated and passionate about our belief in Fairies and our art – he has enriched our lives.

I thank my mother for her influence on my childhood with fairy art books, my Dad for his magic in the garden, brother Mark and sister Michelle for our love together and childhood drawing competitions, my children Charlotte and Eleanor who have seen the light and love appear, and share it all with me. I thank Per Arne in Sweden who rediscovered Ann Mari Sjögren and made my childhood dream to meet her come true, and the wonderful fairy artists in Devon who knowing my life's story have encouraged and inspired me: Brian and Wendy Froud, Alan Lee, Hazel Brown, Marja Lee Kruÿt, Virginia Lee, and many other artists.

Thanks to Albert Gazeley who writes beautiful poems for me (www.poetryworld.us), Elizabeth Jane Baldry who inspired me by playing her beautiful fairy harp (www.fairyharp.com), Ray and Sally Danks (www.filray.co.uk) for support working on websites, Vicente Duque in Colombia for websites in Spanish (www.fairygirls.com/spanish.htm), and Chris Stone and Carly Madden at Collins and Brown whose publishing collaboration has made this book possible.

John Arthur 242–7
Website
www.johnarthur.com
E.mail
john@johnarthur.com

Brigid Ashwood 18–21
Website
www.ashwood-arts.com
E.mail
brigid@ashwood-arts.com

Jasmine Becket-Griffith 22–7
E.mail
jasminetoad@aol.com

Misty Benson 28–31
Website:
www.mistybenson.com
E.mail:
gossamerfaery@hotmail.com

Linda Biggs 32–7
Website
www.fairieforest.com
E.mail
info@FairieForest.com

James Browne 248–53
Website
www.jamesbrowne.net
E.mail
james@jamesbrowne.net

Walter Bruneel 38–9
E.mail
walter.bruneel@skynet.be

Jacqueline Collen-Tarrolly 40–7
Website
www.toadstoolfarmart.com

E.mail
jacqueline@toadstoolfarmart
.com

Kathleen A. Cyr 48–57
Website
www.enchantedscribbles.com
E.mail
admin@enchantedscribbles.
com

Meredith Dillman 58–65
Website
www.meredithdillman.com
E.mail
kyrn@kyrn.org

Andy Duroe 66–71
Website
www.fairydome.com
E.mail
pog@fairydome.com

Liselotte Eriksson 236–41
Website
www.liselotteeriksson.com
E.mail
liselotte@liselotteeriksson.
com

Selina Fenech 72–7
Website
www.selinafenech.com
E.mail
selina@selinafenech.com

Anna Franklin 78–9
Website
www.fairylore.co.uk
E.mail
Annafranklin2@aol.com

Jessica Galbreth 80–1
Website
www.fairyvisions.com
E.mail
fairyvisions@aol.com

Victoria Griffin 82–7
Website
www.victoriagriffin.com
E.mail
vsgriffin@earthlink.net

Suzanne Gyseman 88–91
Website
www.suzannegyseman.co.uk
E.mail
sugysemanart@aol.com

Carrie Hawks 92–7
Website
www.tigerpixie.com
E.mail
tigerpixie@cox.net

Ed Hicks 98–9
Website
www.edhicksfinearts.com
E.mail
edhicksartist@aol.com

Juri Iida 100–7
Website
http://arusu.littlestar.jp/
E.mail
arusu@bf.littlestar.jp

Stathis Karabateas 230–5
Website
www.stathisart.eunet.gr
E.mail
stathiskarabateas@hotmail.
com

Wendy Kathleen 108–15
Website
www.wendykathleenart.com
www.icedreamz.com
E.mail
wendykathleenart@juno.com

Timothy Kobs 116–19
Website
www.tkobs.com
E.mail
fantasticdreams@tkobs.com

Silvia Lugli 220–5
Website
www.artesilvia.it
E.mail
nonnagilda@tiscali.it

Coleen Mcintyre 216–19
Website
www.faerietalesart.com
e.mail
faerietalesart@netzero.com

Karen Miles 128–9
Website
www.karenmilesenchantedart
.com
E.mail
karenscat@yahoo.com

Susan Miller 226–9
Website
www.suemillerart.com

E.mail
angelknock@juno.com

Erin Mincks 120–7
Website
www.pixiedustpaintings.com

E.mail
erealpixie@yahoo.com

Sarah Pauline 130–9
Website
www.fortryllelse.com
E.mail
spkunze@fortryllelse.com

Myrea Pettit 8–17
Website
www.fairiesworld.com
E.mail
myrea.pettit@fairiesworld.com

Natalia Pierandrei 140–1
Website
www.nati-art.com
E.mail
chat_noir@libero.it

Nicole Pisaniello 142–7
Website
http://www.deramis.com
E.mail
art@deramis.com

John Randall York 212–15
Website
www.johnrandallyork.com
E.mail
jrandallyork@yahoo.com

Linda Ravenscroft 148–51
Website
www.lindaravenscroft.com
E.mail
linda@ravenart.fsnet.co.uk

Aimee Ray 152–5
Website
www.dreamfollow.com

E.mail
merwing@dreamfollow.com

Suzanne Richards 156–9
Website
www.mojo.com.au
E.mail
mojo@mojo.com.au

Shano 160–7
Website
www.shano-studio.com
E.mail
shano@shano-studio.com

Ann Mari Sjögren 168–71
Website
www.fairypaintings.com
E.mail
www.fairypaintings.com/
contact.shtml

**Terrell Smith-Dorfeo
172–5**
Website
www.TerrellzToonz.com
E.mail
TerrellzToonz@comcast.net

**Paulina Stuckey-Cassidy
176–83**
Website
www.restlessmoongallery.com
E.mail
orchidwitch@mail.stn.net

Ryuichi Takeuchi 184–9
Website
http://members.jcom.home.
ne.jp/ryu/
E.mail
ziki.lai@ro.bekkoame.ne.jp

Melissa Valdez 190–5
Website
www.thegypsyfaeries.com
E.mail
indiangypsie@hotmailcom

Maria Van Bruggen 202–7
Website
www.elfies-world.com
E.mail
info@elfiesworld.com

Linda Varos 196–7
Website
www.lindavaros.com
E.mail
varos@telerama.com

Maria J.William 198–201
Website
www.mariawilliam.net
E.mail
maria@mariawilliam.net

Barbara Yochum 208–213
Website
www.spiritpainter.com
E.mail
itsbarb@bellsouth.net